MURDER & MAYHEM
IN
NASHVILLE

MURDER & MAYHEM
IN
NASHVILLE

BRIAN ALLISON

THE
History
PRESS

Published by The History Press
Charleston, SC
www.historypress.net

Copyright © 2016 by Brian James Allison
All rights reserved

First published 2016

Manufactured in the United States

ISBN 978.1.46713.573.3

Library of Congress Control Number: 2016938319

CONTENTS

ACKNOWLEDGEMENTS

A ny project like this cannot come to be without the input of some wonderful people. And oftentimes, the only thing an author can do in return is give them a well-deserved and sincere "thank you."

So here goes. Many thanks to Candice Lawrence, my editor at The History Press, for all the help and support and for believing in this book and getting it to press in the first place.

To Ken Fieth and Kelly Sirko at the Metro Nashville Archives, thank you for letting me look through your wonderful collection of the city's past. For anyone looking to research Nashville's often tumultuous past, stop in and see them—it's a treasure-trove of historical gems. And Kelly, I totally used your suggestion for the title of the piece on Prince Greer. It's perfect.

To Kelly Wilkerson, Tom Kanon, Heather Adkins and Steve Rutherford at the Tennessee State Library and Archives, thanks for putting up with all the little aggravations that go with helping the lost find their way. By the way, the TSLA is another underrated treasure, not just for Nashville, but also for the entire state of Tennessee.

To Valerie McCauely, a very, very sincere thank-you for allowing me to use the wonderful photo of your ancestor Officer Benjamin F. Dowell and his wife, Alice. Also, thank you for the stories you shared about them and their children. Even though he died so long ago, it helps to put into perspective that all of those affected by these tragedies were real human beings and loved by those who remembered them.

ACKNOWLEDGEMENTS

To Cynthia Gore at Mount Olivet Cemetery, thank you for being so warm and helping me locate the final resting places of some of these folks. Again, if you're looking for local history, you can't beat a visit to the resting place of those who went before. A stroll through this beautiful Victorian cemetery is a moving experience and really makes you realize the power and influence of the former residents of the city.

To my friends Lydia Melton, Josh Hall, Jason and Rachel Kirk and all the rest—thanks for putting up with a nut with a love of old and often creepy stories and for keeping me as sane as I can be. I hope you like the book—I think it's very "vampyr."

To the many fellow researchers, writers and historians who helped me run down obscure facts and sources: Bill O'Neal, Jim Knight, Daniel E. Sutherland, the Sisters at St. Cecilia and everyone else I forgot to mention, thank you!

And finally, to Mom and my brothers, thank you very much for the love and support you've shown over the years. Look at this—I made a book! Who would have thought?

INTRODUCTION

Nashville today is a modern city much like many others. Steel, glass and concrete towers take up much of downtown, offering all the goods and services one would expect from a vibrant and thriving town. The population as of this writing is over 600,000 (about the same as Boston), so there's no denying that the city has "arrived" as a major metropolis.

However, that progress comes at a price. Nashville has a short memory and always has. Ever since its beginning, the town has never really revered its past, and a sense of "out with the old, in with the new" has always prevailed. The result is that little remains today to remind a visitor of the town's colorful history.

There are notable exceptions, and if you know where to look, there are still places where the veil seems to part for a moment and give a peek into the past. Standing on the platform at Union Station Hotel on a quiet Sunday morning, you can just about picture the clouds of steam and the rush and confusion as crowds exit the cars while porters roll cartloads of baggage toward waiting taxicabs—as they did every day until forty years ago.

At Fort Negley a few miles away, sometimes it is possible to picture lines of Union troops drawn up on dress parade, weapons flashing in the sunlight as their officers' commands echo off the rocks around them, preparing for a battle they would never have to fight.

Stand near the Hermitage Hotel, and you can imagine crowds of women in long dresses and large hats, wearing banners and yellow roses as they swarm around the building passing out flyers and reminding people to

support the right of women to vote—a right that was fought for and won in the Capitol Building just a stone's throw away.

Like many cities, Nashville has a long and interesting history, with much to boast about, and there are plenty of museums, cemeteries and landmarks dotting its environs that cater to the interested visitor. But like every town, Nashville also has a different history, full of darker places that it's probably better to be modest about.

There is something fascinating about exploring the shadows of a city and looking into places where, in real life, we would probably fear to tread. Maybe it's the fascination that comes with the forbidden, or maybe it's just some primitive instinct, but many times we just like to hear about people being bad. There's nothing wrong with that—history is supposed to be instructive, and it's just as effective when it's giving an example of how not to do something.

If one knows where to look, there are reminders of this darker past, as well. Stand near the entrance of Printer's Alley and all its gloriously trashy "tourist" enticements, and you can just about picture the elegant mahogany bars and glittering glassware of the "Gentleman's District," where two hundred saloons offered five-cent beer and free lunch for customers—as well as other "diversions," if you knew who to ask.

Down near the riverfront, you can sometimes see reminders of what was once an overflowing wharf, full of steamboats jockeying for position as laborers offloaded cargo before going uphill to blow their wages in the sinful dives of "Smoky Row" just about a half mile up Second Avenue.

Standing in the public square park, you can imagine a well-heeled gentleman in a top hat and black frock coat striding like a gunfighter toward an opponent, fingers on a dirk or pistol beneath his vest and heart full of anger over some imagined slight to his "honor."

This book is intended to be an introduction to some of the more colorful slices of Nashville's past and to lead you off the beaten path into some forgotten territory. It is not intended to glorify those crimes; rather, it's a gentle reminder that not everyone in a city's history made the newspapers for the right reasons. If anything, it may serve as a lesson that people are people, and human behavior really doesn't change much over the years. There is something a bit comforting in realizing our ancestors could be just as frail or pig-headed as we are. They made bad decisions, too.

It is also intended as a reminder of a forgotten segment of the population. While Andrew Jackson, James K. Polk, Captain Ryman and Edward Carmack all have monuments built to their memories, who remembers

Prince Greer, Mary P. Smith, Ben Dowell, Ruth Davenport or Jordan today? They lived quiet lives, well away from the public spotlight, but to the people who loved them, they were more important than any abstract hero. To be able to tell their stories and remind readers that they were also once part of this city's past is very satisfying.

Anyone who undertakes a project like this will tell you the same thing: we've only scratched the surface. Many of the stories here are long forgotten and will be unfamiliar even to a longtime resident. And if you're new to town, you're on even footing with the rest of us. These tales represent just a sampling of the city's more interesting misbehavior, from its founding until the beginning of "modern" times. (Like many historians, I use my own arbitrary dating system; for the sake of argument, I'm using the start of World War II as "modern times.")

So if you picked up this book hoping for some offbeat history, I think you won't be disappointed. The stories presented here are only a sampling, but they should tread new ground for most of us and throw a tiny ray of light into the dark cellar of what was once known as the "Rock City." I hope you enjoy it.

AFFAIRS OF HONOR

Just east of the city stands a museum dedicated to one of its most famous sons. The Hermitage was the home of Andrew Jackson, the seventh U.S. president, whose life defined an era. It is one of the finest museums of its type in the state and does an admirable job interpreting the life of one of the most colorful—and controversial—figures in the nation's history.

He is remembered today for his triumphs, but Jackson had many weaknesses as well, and in many ways they helped define him as much as his strengths. He went far despite an ungovernable temper, a delicate sense of pride and an often uncompromising will. He was, in the end, utterly human.

His strengths and his weaknesses helped bring about the most famous hostile encounter in Tennessee history. On May 30, 1806, Jackson faced off against attorney Charles Dickinson on the banks of the Red River in Kentucky, some forty miles from Nashville. The duel has become famous as one of Jackson's defining moments. But what is less understood is that it was only the culmination of a cycle of violence that had played out over the previous four years and led to the deaths of two men and the wounding of three more.

Nashville was barely twenty years old at the time. The population barely numbered five hundred permanent residents, making it small enough that "big city" crime was not yet a problem. Much of the crime in a place like New York or Philadelphia stemmed from poverty and desperation, but Nashville's first major string of violence was committed by the town's elite. Many of them were members of the legal profession and were quite aware

that their actions went against the law they practiced. And many of them had once been close friends.

As Nashville grew, distrust and political differences split these friendships apart. For example, Andrew Jackson had come to Nashville with John McNairy, who had originally been his mentor. It was McNairy who appointed Jackson to his post as prosecuting attorney when the pair lived in Jonesborough in 1788. But during the next decade, Jackson came to disagree with McNairy and twice opposed him when he ran for office. By 1800, the two men were barely on speaking terms. Each of them had come to the fore of two distinct political factions vying for prominence in the town. It was an

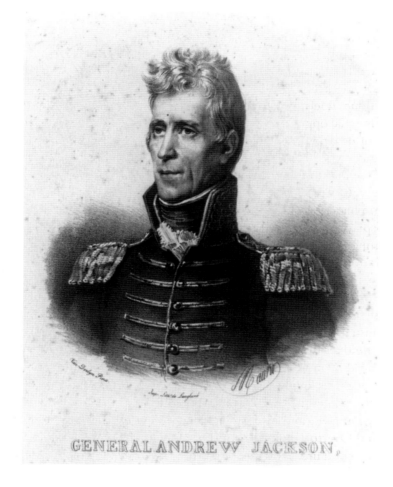

GENERAL ANDREW JACKSON,

Andrew Jackson. The future seventh president was the focal point of quite a bit of mayhem in early Nashville. *Library of Congress.*

atmosphere wherein touchy egos and brittle pride would ensure a small quarrel could easily turn deadly.

At that time, gentlemen of standing had only one recourse if they felt themselves insulted or betrayed: a challenge would be issued to meet on the dueling ground. The practice of dueling was supposed to ensure that the two combatants would meet on equal terms. The weapons were to be as identical as possible. Distances were carefully measured and the rules fully explained so that each participant had an equal chance at victory.

All this ritual was meant to separate "gentlemen"—usually defined as wealthy and respectable members of society—from "common folk," who settled their differences with fists, knives or a shot in the back without warning. Dueling was often seen as a way to show courage and a willingness to put one's principles on the line. Anyone who refused a challenge would be branded a coward. In a day when his reputation was crucial to advancement, such a man would find himself outcast by the whole community.

In real life, duels were rarely that cut and dried. Gentlemen frequently bullied unequal opponents into fatal encounters for trivial reasons. And on a number of occasions, the rules meant to ensure fairness would be bent to the breaking point. In Nashville, it appears that the two rival factions used the "field of honor" to thin the ranks of their opponents. There is more than a hint of a gang war in what was about to occur.

Jackson had a sense of honor that was more finely tuned than many and often displayed a willingness to take the part of a friend whom he felt had been wronged somehow. In the summer of 1805, this tendency would lead him into trouble, as he became embroiled in the quandaries of a hotheaded young friend named Thomas Jefferson Overton.

Overton, a lawyer from Kentucky, was a nephew of Jackson's neighbor and close friend General Thomas Overton. The young man appears to have been unusually quarrelsome, even for the time and place. He had already fought one duel that summer, with Nathaniel A. McNairy, the brother of Jackson's old mentor and current enemy John McNairy.

Their duel was fought on July 10, 1805, and reflected badly on Overton's opponent. While the rules were still being explained to both parties, McNairy fumbled, and his pistol suddenly went off. Luckily, he missed his target, and Overton took his own shot. No blood was drawn, and Overton refused a second fire, saying he'd received "satisfaction without [McNairy's] concession"[1]—implying that when his opponent fired early, he had proven himself no gentleman. McNairy was humiliated and maintained that his

shot was an accident, but the incident led to considerable whispering on the streets of Nashville.

Just over a week later, Overton was in trouble again, this time with a law clerk named John Dickinson. During an argument, Overton clubbed Dickinson over the head with his cane. Among gentlemen, a blow was considered a mortal insult implying contempt and had to be answered. Dickinson promptly issued a challenge, which was accepted. Overton approached Andrew Jackson and asked him to act as his second.

The second was an important figure. It was he who met with the opponent's representative to set the rules for the fight. As the representative of the challenged party, Jackson asserted his right to name the distance between the combatants. Noting that his man was a poor shot, he proposed a distance of only seven feet—so close that the pistol muzzles would nearly be touching. Such short range was unorthodox but not unheard of, and Jackson was using the tactic to cancel out Dickinson's superior skill. At that range, luck would be the only factor.

Dickinson, understandably shocked, refused. In a break with protocol, he named his own terms and declared he would not fight at a distance of less than twenty-four feet. Jackson was flabbergasted and quite correctly said that the challenger was not allowed to name the distance or object to the proposed terms. The young man refused to budge, and Jackson duly advised Overton that Dickinson was essentially cheating and the challenge could now be safely ignored. He even advised his man to beat Dickinson a second time to show his contempt for him. Overton, though, was angered beyond reason. Against his second's advice, he accepted the duel on his opponent's terms.

Anger proved a poor substitute for skill. The two met on July 19, 1806, somewhere near town. The terms finally agreed on were to stand back to back, twenty-four feet apart; turn at the word "fire"; and "advance or not, and fire when they pleased."[2] The first round resulted in two misses. However, on the second shot, Overton fired quickly and missed. Dickinson, taking full advantage of the rules, "advanced" deliberately up to Overton, pointed his pistol from less than a foot away and fired directly into his opponent's chest. Shot through the body and left arm, Overton was critically wounded.

He eventually recovered and seemed bent on seeking a rematch. His rage is demonstrated in a letter he wrote from his sickbed, describing Dickinson as "the greatest monster of depravity, in the shape of a man, that ever disgraced the animal creation."[3] Despite his evident loathing, he would never get the satisfaction he sought. Overton eventually returned to Kentucky and resumed

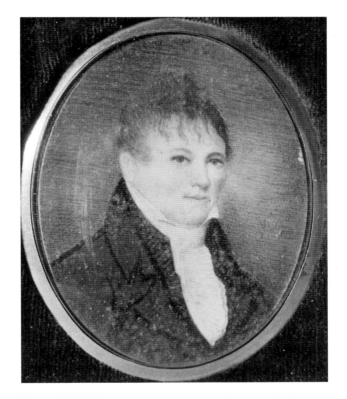

Nathaniel McNairy—attorney, enemy of Andrew Jackson and none-too-successful duelist. *Courtesy Tennessee State Library and Archives.*

his law career. He joined the army at the beginning of the War of 1812 and was killed in January 1813 at the Battle of the River Raisin.

For his part, John Dickinson lived peacefully in Nashville for the remainder of his life and by all accounts was well liked by most of his acquaintances—Overton excepted. He fell victim to consumption and outlived his old foe by only two years, dying on July 7, 1815.

Jackson's role in these affairs led to much ridicule from his many enemies in Nashville. The McNairys especially felt no warmth toward him. Still smarting from his own poor performance on the field, Nathaniel later wrote sneeringly of Jackson's arrangements for the Overton-Dickinson affair, chiding him for attempting to "make children fight at six feet distance." Things were only bound to get worse.

As the fall of 1805 wore on, Jackson found himself in a new dispute with another formerly cordial acquaintance. Captain Joseph Erwin was another

local planter and landowner who was especially renowned for the fine string of racehorses he raised at his farm, Peach Blossom, on the southern outskirts of Nashville. At the time, Jackson owned Truxton, arguably the finest horse in the state, and Erwin suggested a match between Jackson's horse and his own Ploughboy, a locally famous mount.

However, the anticipated race had to be cancelled when Ploughboy came up lame, and Erwin had to pay an $800 forfeit. The disagreement that followed is Machiavellian and hard to follow, but suffice it to say there was a slight dispute about how the forfeit was paid, which seems to have been of little consequence to either party. However, the rumor mill soon fired up, and it was whispered that both Jackson and Erwin were complaining that the other party had attempted to cheat on the deal. In the end, it was this gossip more than the actual disagreement that lit the fuse in the trouble to come.

Soon, Erwin's son-in-law, Charles Dickinson, had made things incalculably worse. Often cast as the villain of the piece, Dickinson by all accounts was a brilliant young man and well liked by many who knew him. An attorney by trade, he had supposedly met Jackson at a party in his native Maryland and had come to Nashville at the older man's invitation. Affable, charming and witty and married to the beautiful and much-admired Jane Erwin, Dickinson was as polished as Jackson was down to earth. At least, he was when he was sober.

The bottle was his weakness, and it appears he was an ugly drunk. One evening, while carousing in one of Nashville's taverns, he made several crude jokes about the marital fidelity of Jackson's beloved wife, Rachel. For Jackson, this was considered an unforgiveable sin, and he let Erwin know that he'd best curb his son-in-law's behavior.

As this dispute was heating up, things became complicated by a social-climbing busybody named Thomas Swann, who came barging into the situation uninvited. A recent transplant from Virginia, Swann was attempting to ingratiate himself with Erwin and Dickinson and decided that their quarrel was now also his. He spied on Jackson one day at his store and reported what he said he'd overheard—albeit with some embellishment.

Dickinson confronted Jackson about Swann's tale, and the older man replied that whoever had said such things was a "damned liar." Dickinson smugly told Swann what Jackson had called him, and the young Virginian immediately issued a challenge for "satisfaction." Fatefully, he enlisted none other than Nathaniel McNairy to act as his second.

Jackson considered his real fight to be with Dickinson, not a stand-in. He not only refused the challenge, but he also told McNairy that if Swann

persisted in pursuing the matter, he would publicly "cane" him—a public beating that showed he considered Swann to be his social inferior. Duels were only for gentlemen; if challenged by a lesser light, the gentleman was under no other obligation than to beat his enemy up.

McNairy—who really comes across as a flake—once more acted in a less-than-satisfactory manner. He apparently downplayed Jackson's anger and misled young Swann into thinking that his opponent merely wished to talk things over. It was apparently in this good faith that Swann approached Jackson as he sat before the fire at Winn's Tavern on the public square one cold January morning in 1806.

With a thin smile, Jackson rose and greeted the young man with frosty courtesy, then brought his cane down on Swann's head so hard that he himself stumbled and nearly fell into the open fireplace. As Jackson staggered back to his feet, Swann reached his hand behind his coattails, apparently going for a hidden pistol. Bystanders moved to restrain him, but Jackson pulled his own gun and roared, "Let him draw and defend himself!"

As the barflies ran for cover, Swann froze. He withdrew his hand and swore he had no intention of fighting. As Jackson blasted his ears with a torrent of abuse, Swann turned tail and fled through the growing crowd.

Jackson had made his point. Though Swann continued to press for a duel with his tormentor, Jackson sneeringly refused, pointing out that the youngster was no gentleman; after all, he'd been given a chance to fight and had choked. Swann's reputation in Nashville was all but ruined by the affair. Though he remained around town for the next three years and stayed close to Captain Erwin, he was something of a joke, even to his friends and supporters. He eventually pulled up stakes and sought a more receptive climate sometime around 1809.

In the aftermath of Swann's humiliation, Nathaniel McNairy caused more trouble. He proved to have an unfortunate tendency to run his mouth, and in February 1806, he fired off a scathing letter to the *Nashville Impartial Review* dripping with sarcastic barbs about Jackson's courage. The response was not what he hoped for.

In the article, McNairy haughtily referred to Jackson's friend John Coffee as being a man "not only *honorable*, but *religious*."[4] Whether or not this was intended as sarcasm, it was so taken by the rough-and-tumble Coffee. McNairy was now in deep trouble. Ferocious when angered and fiercely loyal to Jackson, Coffee was nobody to fool with and immediately issued a challenge to McNairy. As dueling was illegal in Tennessee, they agreed to meet over the state line in Kentucky to avoid any legal fallout.

On March 1, 1806, Coffee, McNairy and their seconds met near the state line. Coffee's second, Major John Purdy, won the coin toss to determine who would give the command to fire. He explained that the count would be: "One, two, three . . . fire!" They could aim during the count and then fire at their leisure after the command. Apparently, with McNairy's earlier performance in mind, Purdy repeatedly warned both men not to fire before the command was given.

When both men were ready, they raised their pistols, and Purdy began to count: "One, two . . ." At that moment, there was an explosion, and Coffee staggered backward, shot through the thigh. The impact jogged his hand, and he fired his own shot, which went wide of the mark. McNairy stood wide-eyed, a smoking pistol in his hands; unbelievably, he had fired early once again.

Immediately, Major Purdy approached McNairy with drawn pistol, telling him that he ought to be shot for firing early. Coffee, staggered but not seriously hurt, limped forward on his damaged leg and shouted at his opponent, "Goddamn you, that's twice you've been guilty of the *same crime!*"[5] McNairy stammered that it was an accident and even went so far as to offer to stand still and let Coffee take a free shot. Purdy, though, refused to expose his friend to any more of McNairy's questionable marksmanship, and everyone left the field. The subsequent newspaper accounts of the duel left McNairy with a severely burnt ego. As far as is known, although he lived a long and successful life in Nashville, the affair with Coffee marked the last time he became caught up in an "affair of honor." One hopes that his experiences left him a wiser man.

During all these feuds, the "main event" at the heart of all the bickering had been postponed, but everyone seemed to know it was coming. As early as December 1805, the probability of a fatal encounter between Andrew Jackson and Charles Dickinson seemed increasingly likely. At a Christmas gathering at his house, Captain Erwin had said so much to his son-in-law, expressing an apprehension that he might "flinch" if it came to a showdown. Dickinson replied testily that "he expected nothing else, but the dispute would end in a duel—and if that should take place, he was damned if ever he would flinch!"[6] Their war had begun as an obscure squabble about abstract points of honor, but somewhere along the way it had turned personal. By the spring of 1806, it was clear that when they met, one of them would not be walking away.

Work and family matters kept him from pursuing the matter for a while. Dickinson was absent on business in New Orleans for several

Charles Dickinson, a tragic victim of his own honor. *Author's collection.*

months early in the year, and when he returned, he found that in his absence Jane had given birth to their first child: a son they named Charles Henry Dickinson. However, fatherhood did little to mellow him. Almost as soon as he was home, he picked up the simmering feud where he left off and penned another letter, even more mocking and inflammatory than his previous efforts. Friends of Jackson intercepted it before it was published and reported the matter to him.

This time, Jackson felt he would have to respond or else lose face. He finally issued a challenge, which was immediately accepted. The seconds were appointed. General Thomas Overton would act for Jackson, while

Dr. Thomas Catlett stood in for Dickinson. A friend of both men, Dr. Francis May, was hired as surgeon by Jackson's group. As was becoming customary, the parties agreed to meet on the Red River just over the line in Kentucky. The date would be May 30. And once more, the affair would not go according to expectations.

Dickinson was a quick and natural marksman, and he was heavily favored to get off the first shot. He prepared himself with coolness and confidence. On the morning of his departure, he accidentally woke his wife, Jane, who asked him what he was doing up so early. He leaned down and kissed her, saying, "Good bye, darling; I shall be *sure* to be at home tomorrow night."[7] Tragically, he would keep this promise.

Dickinson was joined by several of the "young blades" of Nashville, and the group rode north in high spirits—laughing, joking and cutting up as if they were heading for a picnic. Dickinson repeatedly practiced his marksmanship on the way and even attempted to "psych out" his opponent. At one point, he cut a string hanging from a tree near a tavern at a distance of twenty-four feet with one shot. Turning to the landlord, he made a request: "If General Jackson comes along this road, show him that."[8]

The mood in the other camp was somber. A good number of friends rode along for moral support as Jackson's party made its way toward Kentucky, but the general rode apart from the rest, quietly discussing matters with General Overton. The two men devised a rather cold-blooded strategy for the fight: Jackson should prepare to get shot. Knowing that his man was not as quick as Dickinson, Overton accepted that he wouldn't get the first shot off and would almost certainly be hit. He advised Jackson to stand braced for the impact with his finger off the trigger so the shock wouldn't accidentally cause him to fire. After the smoke cleared, he could then take careful aim and make his shot count. Even if Jackson's wound turned out to be fatal, they reasoned, he could still stand long enough to kill his opponent.

Jackson spent the night before the duel at Jacob Miller's tavern, while Dickinson stayed two miles away at William Harrison's house. By all accounts, both parties spent the night in pleasant conversation with their hosts.

At first light, they met in a clearing on the bank of the river. The preliminaries took only a few minutes. A coin was tossed, and Dickinson's second won the choice of the ground, meaning he could place his man in the position that gave him the best advantage from sunlight or background interference. However, General Overton won "the word," or the right to give the instructions to the duelists—a fact he believed was crucial to Jackson's survival.

Once the two men were in position, pistols in hand, Overton asked both men if they were ready, and both said they were. Then, instantly, without giving them time to think, he shouted the one word: "FIRE!"

Startled, Dickinson acted as Overton hoped he would: he raised his pistol and jerked the trigger. He proved an excellent shot—a puff of dust burst from Jackson's coat front, and the general staggered slightly, clamping his left arm across his chest. Overton was alarmed, but as the smoke cleared, it revealed Jackson standing firmly, pistol unfired, his face tight and determined. In shock, Dickinson took an involuntary step backward and raised his hand to his mouth. He gasped, "Great God! Have I missed him?"[9]

Immediately, Overton put his hand on his pistol butt and took a step forward. In dueling, if a principal left the field before both parties fired, the other man's second was allowed to shoot him. Angrily, he roared, "Back to your MARK, sir!"[10] Dickinson braced himself, stepped up to his place and stared at the ground, waiting for the inevitable.

Jackson raised his own pistol, taking careful aim. Slowly, deliberately, he pressed the trigger. The stillness was broken by a hollow click. The pistol had jammed at the half-cock position. It had neither snapped nor fired.

This was an awkward position. Technically, a malfunction such as this could be seen as a "snap," with the rule of dueling holding that "a snap was as good as a shot." In other words, Jackson's pistol having misfired, both combatants should put their pieces down, reload and take a second shot. Later, Jackson would receive much criticism on this point.

On the other hand, the flint had not connected with the steel, and a case could also be made that the weapon had not "snapped"; therefore, the misfire didn't count. Certainly, nobody present on the ground seems to have known what to do. According to Dr. Catlett, Jackson calmly nodded to both seconds, and neither made any protest.[11] Then he recocked the piece and once more took deliberate aim.

This time, the pistol fired. Dickinson staggered, turned pale and slowly sank toward the ground, the left leg of his trousers rapidly turning red with blood. His friends grabbed him and eased him to the ground, placing his back against a bush as they tore open his coat and waistcoat looking for the wound. To their sorrow, they saw that the ball had torn through his abdomen just below the ribs, severing several major blood vessels. Even with modern surgical intervention, it would be a very dangerous injury. In the days before internal surgery, Dickinson had no chance at all.

After confirming that Dickinson was out of the fight, the Jackson entourage turned to leave. A short distance off, Jackson's surgeon, Dr. May, suddenly

noticed Jackson's stocking, which was stained with blood that had flowed down his body inside his clothing.

"My God, General," he said, "are you hit?"

Jackson shrugged and replied, "Oh, I believe that he has pinked me a little" and urged the doctor to be quiet about it.[12]

Once they were in a quiet place, May examined Jackson's wound and quickly realized how close his patient had come to death. Dickinson had hit him exactly where he had aimed: right over the heart. But the ball struck a brass button on Jackson's chest, which turned it off course. It had plowed across his body at a shallow angle, breaking a rib and cutting a gouge from the breastbone before lodging in the muscles of the chest. Andrew Jackson's life had been saved by a matter of about two inches.

Later in the day, Dr. May brought a bottle of brandy to the dying Dickinson at Harrison's Tavern and was told by Dr. Catlett that the case was hopeless. When Dickinson groaned, "How did it happen that I missed the damned rascal?" May turned away. Jackson had issued him orders not to give any information. He wanted the young man to die without the satisfaction of knowing how close he had come to killing his opponent.[13]

A rider was dispatched to Nashville to fetch Jane and carry her to her husband's side. She immediately left and rode all night, but it was a race she couldn't win. All day long, Dickinson steadily lost ground. He was in terrible agony much of the time, and there was little his doctor could do to alleviate the pain. Around nine o'clock that evening, Dickinson looked up from his bed in the dingy little room and asked Dr. Catlett why he had put out the lights. They were his last recorded words. Five minutes later, he passed away at the age of twenty-six.

Jane had crossed the state line near daylight and rounded a bend in the road just in time to see an awful sight. A rickety wagon was jerking down the rutted road toward her, surrounded by grim-faced gentlemen on horseback. As she drew closer, she could finally see what she already knew: Charles was dead, his blanket-covered body bouncing in the wagon bed. There are no descriptions of what must have been a heartrending trip back to Nashville.[14]

Jackson had arrived before the body of his enemy and was laid up in great pain at his Hermitage, flat on his back from the damage done by Dickinson's bullet. However, the sorry affair would not be allowed to fade away without one more bit of drama.

When some of Dickinson's supporters asked editor Thomas Eastin to use black borders around his columns in the next issue of his *Impartial Review* as a sign of respect for the deceased, Jackson hit the ceiling. Considering it

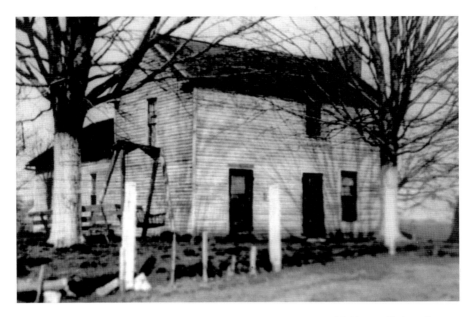

A twentieth-century photo of the William Harrison house, where Dickinson died on the evening of May 30, 1806. *Courtesy Logan County, Kentucky Historical Society.*

an insult, he fired off a defiant letter saying that since the public was not in mourning for Dickinson, it would be inappropriate to use a mark of respect usually reserved for a great hero or head of state. Further, he demanded that the names of those who signed the petition be publicly printed. The implication was clear: Jackson wanted to know his enemies by name.

In the end, Eastin stood by the word "impartial" in his paper's title. He used the black borders as requested but also printed the names of forty-seven of the petitioners. Twenty-six others had asked that their names be removed from the list. It is a telling fact that the published names included some of Nashville's most prominent leaders. Some of them were also related to some of Jackson's staunchest supporters, indicating how deeply the community had been divided.[15]

There was one last postscript to the affair. Jackson wrote to Thomas G. Watkins, lambasting him as one of the principal movers in the "newspaper" incident, and dared him to issue a challenge to fight. Watkins ignored the provocation, even after Jackson's ally Thomas Claiborne had beaten him with a cane at Winn's Tavern. There had been enough blood. In the end, the affair petered out as it had all begun—with a rather childish exchange of letters in the newspapers.[16]

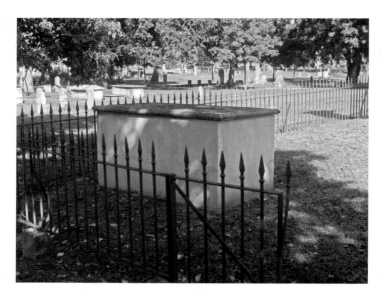

After his rediscovery in 2007, Charles Dickinson was reinterred in the
Nashville City Cemetery. *Author's photo.*

On June 3, 1806, the body of Charles Dickinson was buried near Peach
Blossom, the home of his father-in-law. The family was crushed by the loss
of their loved one and soon moved away from Nashville, finding a new and
prosperous life on the frontier of Louisiana. In time, the old family homestead
fell into decline, and in the twentieth century, Peach Blossom was developed
into a modern suburban neighborhood. Around 1926, Dickinson's grave was
vandalized and lost. For decades, debate raged over whether the famous duelist
was still in his original grave or had been returned home to his native Maryland.

Then, in 2007, an archaeologist settled the question after a diligent search
when he located the lost grave site under a lawn on Carden Avenue. After
two centuries, all that remained was the outline of a hexagonal coffin and a
single finger bone, but it was enough to solve the mystery.

On June 25, 2010, with a small crowd watching, the few remaining fragments
of Dickinson's mortal remains were moved to the Nashville City Cemetery
and reinterred with honors. Long remembered as an arrogant "villain" of the
Andrew Jackson saga, in recent years, he has been looked on more objectively as
a man of his time and place who was much like Jackson in many ways.[17]

He had his demons, but he also showed great ability. Given a chance, he
might have been one of Nashville's great names. Like Jackson, he gambled
everything on his honor and reputation. Unlike Jackson's, his luck ran out.

2
GENTLEMEN BEHAVING BADLY

I t is ironic that Andrew Jackson was so often involved in the annals of early Nashville mayhem. His undoubted talent and self-assurance took him from the depths of poverty to the highest office in the land. Unfortunately, that same self-assurance made him unwilling to back down or compromise, and he could easily slip into obnoxious bullying of those he saw as a threat. A decade after the Dickinson affair, Jackson's demons led him into yet another fight—one that remains among the most embarrassing of his career.

Despite some backlash from the duel, Jackson remained prominent in Nashville society. And along with his town, he was soon in the forefront of a national crisis.

In June 1812, Congress declared war on Great Britain, and Tennessee was soon asked to send a draft of volunteers for the war effort. The War of 1812 would mainly be fought in the North and Northwest, far away from Tennessee's borders, but another old adversary would bring the war uncomfortably close. A civil war within the Creek Nation in what is now Alabama soon spilled over into hostilities with white settlers, and an unbelievably brutal war erupted across the southern frontier. This dual war with the Creeks and the British would eventually make Andrew Jackson a national hero.

During the war, Jackson would prove a natural leader. He was resourceful, brave, incredibly tough and possessed of an iron will that often turned an impossible situation around. His mettle would be demonstrated early on, as the Tennessee militia was ordered to New Orleans to fend off a feared British strike against that city.

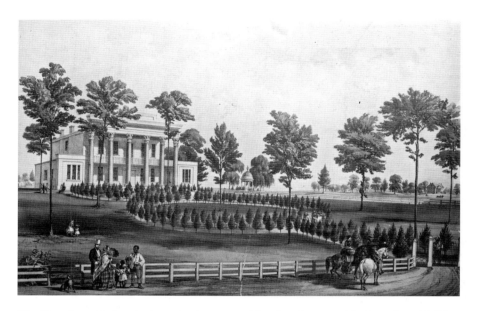

The Hermitage, Jackson's plantation home, was his refuge from trouble throughout his life. *Library of Congress.*

After a nightmarish march in winter weather that left his men cold, ragged and hungry, they arrived at Natchez, Mississippi Territory. There, they were told to halt. Jackson was curtly informed by Secretary of War John Armstrong that the threat had not materialized and his militia was no longer needed. However, the government was unwilling to pay for their return, so essentially they were thanked for their service and left stranded in Mississippi.

A furious Jackson did what the government would not and paid all expenses of the return trip to Tennessee out of his own pocket. He marched with them, sharing their suffering, sometimes walking while a sick man rode his own horse. By the time he returned to Nashville, his men had bestowed a new nickname on him. He reminded them of the toughest tree in the forest, and gradually Jackson became known by his now-legendary title: "Old Hickory." It is said to be one nickname he was truly proud of.

The Natchez expedition was typical Jackson: by sheer will, he pulled a triumph from the teeth of a disaster. However, as so often happened in his life, the high point was soon followed by an embarrassing low. Inadvertently, the weeds that were to trip him up were planted during the low points of the Natchez debacle.

It must be said that Jackson played favorites. Young, ambitious men of a similar mindset such as Sam Houston, Stockley Hays, Bailey Peyton and others were

Jackson's final duels arose during the War of 1812. He later led his army to victory at New Orleans and became a national hero. *Library of Congress.*

often "adopted" by Jackson, who acted as a friend and advisor to them— in some ways, almost as a father figure. As the march to Natchez began, he was especially close to a young officer by the name of Thomas Hart Benton.

Born in 1782 in North Carolina, Benton was raised in Williamson County, where his family established a settlement known as Bentontown (present-

day Leiper's Fork). The death of his father brought out a great maturity in the boy, and Thomas displayed great drive and ability from an early age, along with a mastery of words and a gift for tact—at least when he was calm. Unfortunately, much like Jackson, Benton was easily excited and had a touchy sense of honor coupled with a quick temper. As a young lawyer, Benton came to Jackson's attention and gradually became part of his circle. When the war started, Benton was made an aide-de-camp with the rank of lieutenant colonel.

In the summer of 1813, Lieutenant Colonel Benton had business that took him to Washington, D.C., and Jackson asked him to take up his case and argue with the bureaucrats to compensate him for the considerable debt he had incurred at Natchez. Benton recalled that he negotiated for weeks with Secretary Armstrong and finally convinced him to issue backdated orders to pay for the troops' travel. By his efforts, Benton recalled in his charmingly immodest way, Jackson "was relieved from impending ruin" as the notes came due that he had used to pay the army's way. He further declared his belief that by doing so, he had kept Tennessee in the war. However, if he was expecting to be hailed as a hero on his return home, he would be sadly disappointed.

In his absence, another "affair of honor" had ruffled Jackson's feathers. Among his other favorites was a Pennsylvania-born merchant named William Carroll, who was serving as a major on Jackson's staff. A squabble had erupted in the ranks, and Carroll became convinced that jealousy over his closeness to the commanding general had resulted in a "conspiracy" among the other officers to "run him out of the country." He had already refused one challenge on the march back from Natchez. Upon their return to Nashville, the "anti-Carroll" forces chose one of their number as a champion to fight the upstart. The man they chose was Colonel Benton's younger brother, Jesse.

Jesse Benton was remembered as a man who possessed "a good deal of his brother's fire and fluency, without much of his talent and discretion."[18] After some sparring between himself and Carroll, Benton felt insulted enough to issue a challenge, and Carroll appealed to his commander and friend to act for him in the matter. Jackson had misgivings, stating that he was too old for such things, and advised Benton to avoid a quarrel if possible. However, Carroll appealed to the general's sense of honor, and once more Jackson was caught in a net of his own creation. On June 14, 1813, Carroll and Benton met in a grove near Nashville.

The affair would be remembered for many years as "a standing joke" in Tennessee.[19] The two men stood back to back, ten paces apart. At the

words, "Prepare . . . fire!" they spun around and leveled their pistols. Carroll was tall and thin, and Benton's ball would have missed had he not put his hand out to steady himself. As it was, the projectile stung Carroll, just tipping his left thumb.

Benton came off the worse for wear, spinning around in "a Stooping position, his body considerably prostrated."[20] Carroll also shot wide of the mark, but unfortunately for Benton, the ball struck the one part of his anatomy that was most exposed in that posture. He was carried from the field and spent several weeks facedown, recovering from his embarrassing wound.

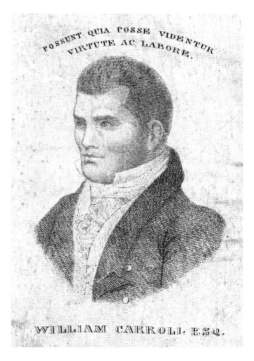

William Carroll. After the war, he would go on to serve a record six terms as governor of Tennessee. *Courtesy Tennessee State Library and Archives.*

Jesse was mortified by the proceedings and began grousing that the thing had been unfair. Specifically, he objected to the unusual act of "wheeling" before firing, which he said had thrown off his aim. As always, the suggestion that he had acted dishonorably infuriated Jackson beyond reason, and Jackson began to vent his spleen against both Jesse and his brother Thomas. About that time, Thomas Hart Benton returned from Washington, dumbfounded to find his brother wounded and himself at war with a man he had considered a friend just weeks earlier.

Quite understandably, Thomas Hart Benton was upset and wrote to Jackson demanding an explanation. Jackson reacted predictably, and a war of angry letters ensued, with insults and threats increasing all the while. Neither man quite challenged the other, although both dared the other to do so. Eventually, Jackson went so far as to threaten to horsewhip his subordinate when they met. Benton was enraged over this attack, which he clearly did not deserve.

On September 3, 1813, the Benton brothers rode into town together on business. To avoid aggravating the situation, they put up at Clayton Talbot's

tavern, also known as the City Hotel. The tavern stood on the north side of the public square, next door to the post office and several doors away from the Nashville Inn, where Jackson and his cronies usually stopped. Both brothers were wary and went heavily armed. This delicate maneuvering was typical for young hotheads on the frontier. Neither wished to be the one to start a fight, but neither intended to back down from one. It was a dangerous game—if the intention was to bluff Jackson, they had miscalculated. He was prepared to push this issue to the limit.

General Jackson rode into town the same day, along with his faithful friend Colonel John Coffee. True to form, they stopped at the Nashville Inn. Coffee later said that they were simply there to visit the post office, although he is said to have "grinned" as he gave this explanation. Certainly, the timing of their arrival was suspicious, and they were far more heavily armed than necessary if they were there to check the mail. Jackson carried a riding whip and wore a small sword around his waist—a weapon almost never seen in civilian life at that time. Both men carried pistols and daggers beneath their coats. The day passed in an uneasy calm, and all adversaries spent the night at their respective lodgings.

At around nine o'clock the next morning, Coffee and Jackson started for the post office, walking slowly across the square while glancing out of the corner of their eyes at Talbot's place. Coffee noticed Thomas Hart Benton standing in the doorway of the City Hotel, glaring at them. He asked if Jackson saw "that fellow." Jackson growled back, "Oh, yes, I have my eye on him."[21]

By the time they emerged with their letters, both Bentons were on the sidewalk in front of the hotel, and Jackson and Coffee opted to use the same sidewalk to go back to the inn. This route led them directly in front of the brothers.

As they passed, the two factions stared each other down, but it was Jackson who made the first move. Raising his riding whip, he whirled on Thomas Benton and howled, "Now, you damned rascal, I am going to punish you. Defend yourself!"[22]

The weapon he wielded at first glance sounds like more of an insult than a threat, but a riding whip customarily had a grip weighted with lead. A blow from the butt end could easily kill a man if delivered in the right place. As Jackson advanced with this formidable club, Benton scrambled to draw the double-barreled pistol he carried in a breast pocket. Without missing a beat, Jackson pulled his own pistol and pointed it at Benton's chest. The younger man stumbled backward as Jackson waved the gun at him, sneering at him to do something. He forced Benton to retreat all the way through the tavern's common room and out the back door.

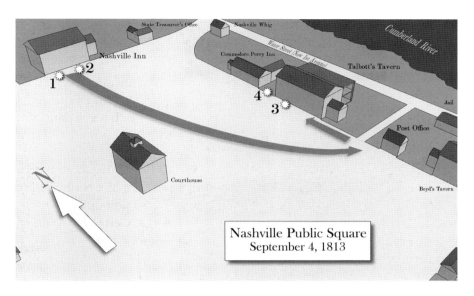

Jackson and Coffee (1 & 2) circled Thomas (3) and Jesse (4) Benton like rival gangsters. When they met face to face, the fireworks started. *Author's diagram.*

Meanwhile, Jesse Benton had stolen a march on them. Pulling his pocket pistol, he ran around the side of Talbot's place until he got to the back porch. Waiting until his brother was clear and Jackson had fully emerged from the back door, Jesse leveled his pistol and let fly.

His pistol was loaded with "buck and ball," a load consisting of one large ball and several buckshot. Jackson was caught flat-footed and knocked sideways. One buckshot and the large ball tore into him, shattering his left arm at the shoulder joint. Another buckshot lodged in the hotel wall, missing him by inches. Jackson fired his own weapon in reaction, while Thomas Benton fired at him twice, missing with both barrels. Jackson collapsed in a bloody heap in the doorway.

At that point, Coffee ran to the door and saw Jackson lying at the feet of Thomas Benton. Thinking he was responsible, Coffee instantly fired his own pistol and missed. With a roar, Coffee raised his empty weapon and prepared to smash Benton's skull with it. Scrambling to get out of the way, Benton stepped backward—and straight into an open stairwell he hadn't seen. He tumbled into oblivion and landed in a heap on the lower landing, stunned and out of the fight. Satisfied, Coffee turned to help his wounded friend.

Meanwhile, the shots brought others running to the scene, among them Jackson's nephews Stockley D. Hays and Alexander Donelson and his friend Captain Eli Hammond. Seeing Jesse Benton standing by with a smoking

pistol, Hays charged. The young man was remembered as "a man of a giant's size, and a giant's strength,"[23] Benton, still limping from his embarrassing dueling wound, was easy prey. Grabbing the smaller man, Hays drew his sword cane and rammed it into his adversary's chest.

Jesse Benton should have been nailed to the wall, but his life was saved by sheer luck. The point happened to strike one of his metal coat buttons, and the blade shattered. Enraged, Hays smashed the squirming Benton to the porch floor. Pulling a dagger from under his coat, he began stabbing him. He stuck Benton in both arms and slashed him across the chest and hands. Desperately, Benton grabbed Hays's coat sleeve and kept him from landing a killing blow.

During the struggle, Benton was thrown around like a chew toy. Eventually, Hays's coat sleeve tore away at the cuff, freeing his hand to strike, but just as he raised his dagger, he was tackled by bystanders, who piled on top of him until he cooled off. Others separated the remaining combatants, and the fight finally ended.

The commander of the Tennessee state militia lay wounded on a battlefield littered with bodies, but not in the way he intended. Jackson was dangerously hurt. After things calmed down a bit, he was carried to his room at the Nashville Inn, unconscious and bleeding heavily.

Neither Benton was seriously hurt, and elated with their "victory," they began to act like a pair of juvenile delinquents. They stood in the square, hooting and whooping, daring Jackson to come out and resume the fight. Thomas Hart Benton even went so far as to snap Jackson's sword blade over his leg, denouncing him as an assassin who had met his match. Eventually, the pair wised up long enough to see that they were the only ones cheering and that many dark looks were being shot their way from among the crowd. Fearing the wrath of Jackson's friends, they left Nashville for the tiny town of Franklin, fifteen miles south, where they rushed their version of the fight into print.[24]

Back at the scene, Jackson was close to death. Lying sweat-soaked on his bed, as white as the sheets from loss of blood, he was attended by several doctors, who probed the wound in his arm. The large ball, after breaking his humerus, had lodged dangerously close to the brachial artery. All but one of the surgeons agreed on the proper course of action: amputation was the only way to save Jackson's life. The arm would have to come off just below the shoulder.

During their huddling, Jackson was semiconscious, drifting in and out, but upon hearing their decision, some of the old fire came back to him. Glaring

up from his pillow, he said in a weak voice, "I'll keep my arm." So final was the statement that nobody argued.

However, the bleeding continued for some time, and by the time they finally managed to get it under control, the blood had soaked through the top mattress of the bed and into the second. Three weeks would pass before Jackson could rise again, and when he rode off to command his troops in the Creek War one month later, he did so with the bad arm in a sling, pale as a ghost and clinging to his saddlebow for dear life. So tender was the wound that he couldn't bear the weight of his left epaulette and left it off his uniform for the rest of the year.

Within a short time, Jackson won renown fighting the Creeks and immortality fighting the British at New Orleans. The tavern brawl that he did so much to start was a humiliating dark spot on his record, but his victories helped the public forget. In time, he would ride his success to high office, and in 1823, he was elected to the U.S. Senate.

When he arrived in Washington City, he found a familiar face waiting for him. After the war, Thomas Hart Benton had shaken the dust of Tennessee from his feet and made himself a power in the West, settling in the vast territory across the Mississippi River. When Missouri was admitted to the Union in 1820, he was elected one of the state's first senators, and one day late in 1823, he found himself serving on the Committee of Military Affairs. The man in the seat next to him was none other than his old friend-turned-enemy Andrew Jackson.

Others moved to separate them, but Benton declined, and the two men acted with stiff politeness toward

Thomas Hart Benton. As a senator from Missouri, he would finally patch up his decade-old feud with Andrew Jackson. *Library of Congress.*

each other. In time, the old friendship began to melt the frost, and within a year, Benton and Jackson had made their peace. When Jackson became president, the two became staunch allies in their fight against the Bank of the United States. At the time he entered office, Jackson still carried the bullet in his shoulder that Benton had placed there years before. A surgeon would eventually remove it in an operation performed at the White House.

In time, they even felt comfortable discussing the matter in a darkly humorous fashion. Sometime before his death in 1858, a protégé asked Benton about Jackson. The former senator reportedly replied in his hyperactive way, "Yes, sir, I knew him, sir; General Jackson was a very great man, sir. I shot him, sir."[25]

Thomas evidently had forgotten that it was his brother Jesse who had actually planted the ball in Jackson's hide. And unlike Thomas, Jesse never did forgive or forget. He lived in Nashville for the remainder of his life and vehemently opposed his old enemy's political ambitions, writing attacks that bordered on the libelous during Jackson's several presidential campaigns. He died in 1843, still bitter over the humiliation he'd suffered three decades before.

For all its stupidity, the affair turned out to be essential to the making of both men. If Benton had not gone to Washington, Jackson might have spent the rest of the War of 1812 crushed under a mountain of debt in Tennessee. And had Jackson not essentially run him out of town, Benton might never have been the great power he later became. In Tennessee, he would have always been second fiddle to Jackson, while in Missouri he found the room needed for his abilities—and his tremendous ego—to expand.

Perhaps with personalities like these, a showdown was unavoidable. In the words of many a western movie to come, Nashville "just wasn't big enough for the both of them."

3

GROWING PAINS

Nashville really began to come into its own following the War of 1812. After a disastrous fire swept through the little collection of log cabins and frame structures in 1814, the town council decreed that all new construction would henceforth be of brick. The little town would retain reminders of its frontier days, but it took on an increasingly cosmopolitan air in the next few decades.

The rise of the steamboat led to a new prosperity as well, connecting Nashville to the factories and farms of the North and West and the lucrative cotton and sugar markets of the Deep South. This new wealth fueled rapid

Nashville around 1832 looks peaceful enough in this image, but trouble was just below the surface. *Library of Congress.*

growth, and the little town became a proper city in the years leading up to the Civil War.

These were golden years for the community in many ways, but the growth also led to Nashville's first real problems with "big city" crimes. Counterfeiting became a problem, as did vice and gambling. The population expansion led to an increase in poverty and desperation, which in turn led to an increase in burglary and theft of all kinds by those who had to struggle to survive.

A TANGLED WEB

One of the problems facing the historian is that some of the most fascinating stories come from incomplete sources. One of the most intriguing crimes in Nashville's history took place on the plantation of Andrew Jackson's old friend General Thomas Overton. Overton lived on his plantation, Soldier's Rest, about five miles from the Hermitage in a bend of the Cumberland River. In October 1819, his plantation would be the scene of a murder so unusual that it might have broken new legal ground at the time. Unfortunately, the court records give frustratingly few details.

There are no details of how William O'Briant met his death, but when his body was found by a man named Nelson Jones, something raised Jones's suspicions of foul play. After an inquiry, he had one of Overton's slaves, a man named Israel, arrested and bound. It can be imagined that Jones used none-too-gentle questioning, but however it came about, Israel confessed to killing the overseer.

So far, the case reads like many others of the time. After all, the overseer acted as the slave owner's "enforcer," meting out punishment on behalf of the master. Murders of overseers at the hands of abused workers were not terribly uncommon in the antebellum South, but what happened next put the case apart from others and hinted that Israel might not have simply been acting the part of a wronged slave striking back at his tormentor.

During the interrogation, Israel said he had acted in concert with someone else during the killing, and on the strength of his confession, the accomplice was arrested. It turned out to be none other than Mary Ann O'Briant, the widow of the murdered man. Both she and Israel were immediately handed over to Sheriff Thomas Hickman of Davidson County, who put them in jail until their trial.

All that remains today of Thomas Overton's Soldier's Rest plantation is the family cemetery on Donelson Avenue. *Author's photo.*

The news that a white woman was on trial for conspiring with a slave to murder her husband was big for the day, and the story appeared in newspapers as far afield as Washington, D.C. Israel went before the judge first, and on November 4, 1819, he was convicted of murder and sentenced to death. His hanging was scheduled to take place on the third Friday of the month, just outside the city limits.

On November 8, Mary Ann O'Briant stood before Judge Thomas Stuart in the drafty little courthouse on the public square, where she pleaded "not guilty" to her husband's murder. Her trial took three days, with the first two taken up with legal wrangling. Her attorneys filed a series of exceptions objecting to the evidence against their client and specifically the evidence given by her alleged co-conspirator, Israel.

At the time, African American testimony against a white defendant was not allowed under Tennessee law. As much of the evidence against Mrs. O'Briant originated in the confession extracted from Israel, her counsel argued that it was inadmissible in court. It was a clever strategy, but as often happens, there was a loophole in the argument. The judge ruled

that since the confession was obtained by Nelson Jones, a white man, and since Jones would be testifying about what he heard rather than Israel testifying in person, the evidence would be allowed into the record. The trial then proceeded.

The minutes of the case have not survived, so whether the evidence was flimsy or the all-male jury was squeamish at the thought of hanging a woman cannot be determined at this late date. What is known is that on November 11, 1819, Mary Ann O'Briant was found not guilty of the crime of murder. The court ordered her "accquited [*sic*] and discharged without costs." She walked out of the courtroom that same day a free woman.[26]

For Israel, there would be no escape. On November 26, 1819, he was led from the jail and hanged on a gallows that had been erected "at the forks of the road leading from Nashville one part going to Jno. Buchanan's and the other to Jno. Rains." Today, the site where the gallows stood is close to the current location of Union Station Hotel on Charlotte Avenue.[27]

Bad Medicine

Even during Andrew Jackson's day, the formal duel, with its seconds and attendants, was a dying custom. In its place arose a new means of settling a dispute known a "recounter"—or, more plainly, a "street fight." It was a less sporting but more practical way of doing things. A challenge would still be issued, but after that, both parties would arm themselves and go on the hunt for each other. When they spotted their enemy, they could shoot on sight with little warning. In the post–Civil War West, this custom would evolve into what would become known as a gunfight.

One of the more interesting of these recounters involved two out-of-towners on either side of the political spectrum. Gideon C. Matlock was from Carthage, Tennessee. He was a devoted Democrat and supporter of former governor James K. Polk, who lost to James "Lean Jimmy" Jones in 1840. While stumping for reelection two years later, Governor Jones accused the Polk camp of misrepresentation. Specifically, he accused Matlock of lying about his record.

Taking to the press to defend himself, Matlock wrote a blistering letter accusing the governor himself of lying and intimating that if he were a real man, Jones would issue a challenge to fight. As it was, "Lean Jimmy" ignored the provocation, but one of his friends took up the gauntlet.

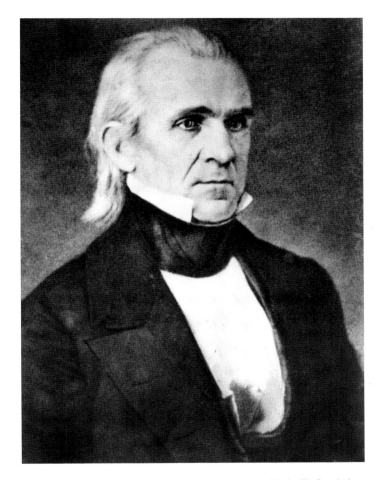

James K. Polk. An argument over his politics at the Nashville Inn led to the death of Jesse A. Bryan in 1843. *Library of Congress.*

Jesse A. Bryan was described as young man of "excellent traits of heart and character" but "of a proud and sensitive nature, that could not brook aught of insult."[28] A native of Clarksville—"Lean Jimmy's" hometown—he was a good friend of the governor and took Matlock's remarks personally.

Arming himself with a pistol and a box of "pills," he told friends he intended to publicly confront Matlock and force him to apologize—and to literally "take his medicine" at gunpoint. In plain speak, the "pills" were laxatives, and Bryan intended to force feed them to Matlock in order to—as he charmingly put it—"work the Polk juice" out of him. His friends told him

it was a bad idea, but Bryan went gunning for his rival on the muggy evening of July 19, 1843.[29]

It appears that Matlock tried his best to avoid trouble. When word came of Bryan's threats, he checked out of the Nashville Inn and sent for his luggage as he prepared to take the stage back to Carthage. He forgot his wallet, though, and when he went back to the inn for it, he came face to face with Bryan. Even after Bryan called him a "damned liar" and tried to knock his hat off, Matlock attempted to walk away. His adversary chased after him, though, and Matlock finally drew and fired. Bryan staggered, firing a shot into the floor before he collapsed with a bullet lodged near his heart. He died a few hours later at the age of twenty-eight. Bryan fled but soon after he was arrested in Columbia—coincidentally, Polk's hometown—and brought back to face the music.

At trial that October, the "pills" were the determining factor. Matlock's counsel maintained that if "A threatens to take B to take a box of pills . . . by using force, or deadly weapons . . . and B immediately kills A with a deadly weapon, this would be excusable homicide." Even though he drew first, Gid Matlock was acquitted on the grounds of self-defense. In the end, the laxatives were ruled a deadly weapon.[30]

Matlock went on to serve as a commissioner in the Bureau of Indian Affairs under President Polk, which critics cynically suggested was a reward for silencing Bryan's criticism two years before. Despite the naysayers, he seems to have been conscientious in his duties and served in office until his death in 1856. He is buried today in Council Bluffs, Iowa.

THE CHAINS THAT BIND

The shadow of slavery was present everywhere in early Nashville, and not just in the fields of the outlying plantations. Servants in homes and hotels were often enslaved, as were coachmen, hackmen, day laborers and factory workers. Sometimes they were owned not by individuals but by the firms that used their labor.

The constant friction between those under the yoke and those who held it often led to paranoia, as slaves made desperate—and sometimes violent—bids for freedom and were in turn subjected to brutal reprisals.

A fascinating but frustratingly vague report talks of one such incident occurring on the "quarter" of John Thompson's Glen Leven plantation (still

standing on Franklin Pike south of town). Word had come of a runaway being harbored by one of the slave families, and the feared "patrollers" were sent to get him. The "patrol" system was made up of white men in the area who acted as a police force against the slaves. In this case, it seems, the patrol got more than it bargained for.

On December 28, 1844, the raid took place, and the men burst into a house where dozens of slaves were gathered. They announced that they had come for the runaways. "Scarcely were the words spoken when the first man who entered was knocked down," and a general free-for-all ensued, with several of the white men beaten badly by the men in the house. According to the report, a large group of slaves descended on the scene, chasing the outnumbered patrol from the house. A cry of "Kill them!" went up, and the slaves reportedly pulled a number of pistols. There were enough guns firing that the scene resembled "the flashing of fireflies in August," and one of the patrollers was shot in the arm before retreating.

Two days later, another raid was met with resistance, and one of the patrol was beaten badly. This time, though, they accomplished their mission and apprehended the fugitive they were after. After that, the story fades away, and no follow-up report has been found so far to detail what happened next in what surely is one of the more remarkable incidents of the era in Nashville.[31]

Sometimes the strain of everyday life in bondage could be too much. Such was the case for Susan, a twenty-seven-year-old woman owned by a Mr. Jetton of Nashville. Called a "trusty, good and faithful servant," she was sent to work for the family of Sarah Polk, the widow of President James K. Polk, at her home on Vine Street. A serious bout of illness seems to have affected Susan's mind, and her behavior became erratic and alarming. She was "attentively watched" by other slaves and the household, but despite this, she managed to gain possession of a knife. On November 14, 1861, Susan killed her two children, an infant boy and girl, and then cut her own throat. A doctor was summoned but gave her little chance to recover.

The unnamed infants were buried the following day in the "Negro Lot" of the Nashville City Cemetery. Three days later, Susan succumbed to her wounds and joined them in death. The cemetery records still bear the heartbreaking notation that she was laid to rest "in grave with children." Their shared grave is unmarked today.[32]

Much of the violence was directed by owners toward those enslaved, but sometimes there were struggles among the slaves themselves. The lot of humanity is often conflict, and the slave community was as subject to rivalries, love triangles, greed and jealousies as any other. A case in point took

Polk Place, on Seventh Avenue, was the scene of a tragic murder-suicide in 1861. The house was demolished thirty years later. *Author's collection.*

place at Clover Bottom, the plantation of Dr. James Hoggatt on Lebanon Pike east of the city.

John McCline was born into slavery in the ramshackle line of cabins near the "big house" on Hoggatt's estate. His memoirs paint an especially vivid picture of the day-to-day existence of those who lived in the shadows of the farm. McCline grew up in an ugly world. He described Mrs. Hoggatt as "extremely kind" because she "seldom, if ever" beat anyone with the rawhide whip she carried.[33] However, overseer William Phillips was remembered as "brutal, ignorant, and a perfect type of the poor white trash of that time," who used a gun, a mean dog and the lash to enforce the owners' will.[34] Punishment for minor lapses or not meeting set tasks were commonplace. Then one day, an act of violence occurred that shocked the entire plantation community—as much for the identity of the accused as for the act itself.

One beautiful day in the spring of 1859, the head gardener went to the seed house to sort out his seeds for the spring planting. His name was Jordan, and he was about fifty years of age. Accompanying him was a much younger girl named Cynthia, whom McCline remembered as a beautiful but oddly sinister figure. When speaking of the widespread belief in ghosts, he once recalled that Cynthia claimed she was never afraid of them "or of meeting

anything more terrifying than herself."[35] Jordan was sweet on the bewitching girl, but she had evidently been discouraging his advances for some time.

After a while, Mrs. Hoggatt asked where Jordan was, as nobody had seen him in hours. After a thorough search turned up nothing, Jordan's daughter Laura entered the seed house, where she was confronted with a terrible sight. Her father lay dead on the floor with blood pooling around his shattered head. Laura's screams quickly brought to the scene a crowd, who conducted an investigation. It turned out that Jordan had been struck over the eye with a wooden mallet hard enough to fracture his skull. After he was down, he was finished off with a knife to the chest.

As Jordan's grief-stricken family carried him back to their cabin to prepare him for burial, Dr. Hoggatt returned from a trip to town and immediately began asking questions. Unfortunately for Cynthia, there was only one suspect. She was the last and only person to be seen with Jordan that morning, and the doctor ordered her brought to him. Searchers found her sitting on a fence, crying miserably, and she was dragged to the washhouse, where she was tied up.

Jordan's body was carried to the slaves' burying ground on the plantation in an old cart, "followed by every soul on the place." Meanwhile, Dr. Hoggatt carried out a terrible inquisition on Cynthia at the washhouse. Taking his coat off and rolling up his sleeves, he lashed her back with a cowhide whip. After each blow, he stopped to ask, "Why did you kill Jordan?" And each time, Cynthia desperately responded, "Master, I didn't do it!" After beating her into unconsciousness, he finally relented. She was in bed for two weeks recovering from the whipping.

No further repercussions seem to have come from Jordan's death. The killing was handled internally by the Hoggatts, and the outside law was not brought into play. McCline, like many others, assumed she had killed him when the older man made one advance too many. Perhaps. But one intriguing statement may hint at another suspect. McCline remembered that a new coachman, Jesse, had recently joined the household, and from that point on, if Cynthia "ever had any affection for Jordan, it was readily transferred to the handsome new coachman."[36]

So was it a murder by a sinister seductress? Or an act of self-defense against an obsessive aggressor? Or perhaps a fight between two rivals for the young girl's affections? Like so many other stories of slavery, the truth lies lost in the past, and only the crumbling quarters bear witness to the many life-and-death dramas that once took place out of sight of the city.

THE SCARLET WOMAN

As with many growing communities, Nashville attracted the typical vices favored by river men and farmers "taking in the town." There was a sprawling red-light district that came to be known in the decade before the Civil War as "Smoky Row." Here were the lower sorts of saloons, back-alley gambling joints and an eyebrow-raising number of brothels.

Life for the "fair but frail" who worked in these places was often short and brutal. Some of them were looking for a way out of poverty, while others fell into the old Victorian trap of being "seduced and abandoned" and found themselves locked out of "polite" society. Modern folks sometimes cast these "scarlet women" as glamorous figures. In truth, abusive clients, drug

Ladies like these were the attraction on "Smoky Row" for twenty years. Mary P. Smith was only one of many who met a sad end there. *Author's collection.*

and alcohol addiction and violence from colleagues and lovers meant they burned out quickly and rarely made it to the age of thirty.

One of the more unusual stories to emerge from the depths of "Smoky Row" is that of a young woman known as Mary P. Smith. Born in Maury County, in her youth she received a refined education at "one of the best female schools in Tennessee," quite possibly the Athenaeum in Columbia. However, "in an evil hour," she fell in love and acted accordingly. When her parents found out that she had been "dishonored," they kicked her out of the house. With nowhere to go, she made her way to Nashville and went to work in one of the brothels sometime in the spring of 1852.[37]

After a year and a half of "the life," Mary found herself in an upstairs room on Cedar Street (now Charlotte Avenue), across from the Verandah Hotel, with an all-night client. At daybreak on October 26, 1853, her "paramour" woke her and prepared to shoo her off so he could start his day. Mary crawled out of bed and went to a nearby dresser. Pulling a pistol from a drawer, she remarked that "she presumed he had become tired of her," then pressed the muzzle to her chest and pulled the trigger. The ball lodged in her heart, and she died almost instantly.[38]

The "accomplished, handsome, and interesting girl" was temporarily buried in the City Cemetery in preparation for transport to her former home in Columbia. Only nineteen years old at the time she died, Mary left little record of who she really was—and her name was almost certainly false. However, one newspaper published an intriguing clue, asserting that she was a niece of General Gideon Pillow, President Polk's onetime law partner and a hero of the Mexican War.[39] Nothing has been found to confirm this, and her short and sad life remains full of unanswered questions. She lies today in an unknown location.

4

A DEADLY SEDUCTION

Today, many aficionados of the Old West are familiar with the colorful character known as Ned Buntline. A flamboyant, larger-than-life and scrupulously dishonest man, he was a writer by trade and an adventurer by nature. Born Edward Zane Carroll Judson in New York on March 20, 1821, he took his nautical nom de plume from a short stint in the navy. He drifted through the American landscape from one scrape to another for decades, always seemingly one step ahead of the law. His legacy of dubious literary efforts later helped immortalize such characters as "Wild Bill" Hickok and "Buffalo Bill" Cody.

What is not as well known is that Judson (or Buntline) was once himself the center of a real-life drama that rivaled anything in the lurid fiction he wrote. It was a story of seduction, intrigue and murder in which a young man died, a young woman's reputation was shattered and Judson himself was lucky to escape with his life.

In the spring of 1846, Judson had come to Nashville riding high on a wave of local fame. He had recently acted as a private detective and arrested two fugitives in Kentucky, for which exploit he was given substantial reward. Taking his spoils south, he laid plans to invest in a new newspaper venture with whatever he had left over after a spree in Nashville's many saloons.

It was perhaps in one of these drinking parlors that the burly writer made the unlikely acquaintance of an upstanding young pillar of the community. Robert C. Porterfield was twenty-four—only a year younger than Judson—but there was little else that seemed in common between

Nashville's quiet public square park gives little indication today of the chaos it witnessed in 1846. *Author's photo.*

them. Where Judson was impulsive and footloose, Porterfield was gainfully employed and had started a family. He was a member of the Odd Fellows and volunteered as a member of the local fire company; in short, he was as respectable as Judson was shifty.

The two men did find one thing they had in common, but unfortunately for everyone, it happened to be Robert's wife, Mary Figures Porterfield. Exactly how she and Judson came together is unknown, but the timing could not have been worse. It seems that the Porterfields were going through one of those rough patches common to a marriage. The couple had two children together, but their daughter Mary had lived only a few months before dying in February 1846. Soon after this, perhaps because of the strain on her relationship, Mary had sought comfort in the company of the roguish Judson, and the two were soon enmeshed in a scandalous affair.

It didn't take long for word to get back to the husband—mainly because Judson couldn't keep his big mouth shut. His bragging with the boys in the barrooms was soon conveyed to Porterfield, who was devastated—not to mention enraged. On March 15, 1846, he grabbed a pistol and told his

brother John to come along with him. Finding Judson in town, he immediately lit into the cad as a seducer, a liar and a cheat.

Judson might have been brash, but he was no fool. He did what any self-respecting scoundrel might in the same situation: he denied everything. He later admitted that he "intended to deny ever having said any thing of the kind" about the affair in order to save his own skin.[40] Porterfield didn't believe him and pulled a pistol. He would have shot Judson on the spot had not his brother John grabbed his hand and prevented him. Many later expressed regret that John had intervened. In the confusion, Judson slunk away, and Porterfield went home to confront his wife.

It was an ugly scene that ended with Mary Porterfield in tears, begging forgiveness for her infidelity. Robert calmed down enough to say that he wanted to move past the incident and let bygones be bygones. Judson was the one he really blamed, and he asked only that she break off all contact with the home-wrecker. Mary agreed, but despite her stated good intentions, things were about to get much worse.

The following day, Mrs. Porterfield went to the City Cemetery, probably to visit the grave of her daughter. Not long afterward, Judson joined her,

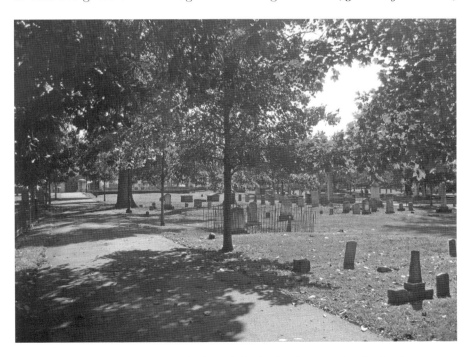

The Nashville City Cemetery played a key role in the deadly game of seduction between E.Z.C. Judson and Mary Porterfield. *Author's photo.*

and the two spent a considerable length of time alone together among the headstones. What they talked about or did is unknown. Perhaps Mary just wanted to tell him it was over to his face. Or perhaps they intended to carry on as before and enjoyed a tryst in a secluded spot. Whether honorable or not, arranged or accidental, this meeting was the last straw. A friend of Robert Porterfield's saw them together and conveyed the news to him. It was said that Porterfield "fell to the floor as if a [pistol] ball had penetrated his heart."[41] It was an apt simile.

The young husband came unglued, and for the rest of the evening, he acted like a raving maniac. He didn't rise until well past noon on the following day. Then, pulling himself together, Robert dressed himself and asked his brother John to walk with him down to the Sulphur Springs, a popular public meeting place. John later claimed they weren't looking for Judson, but it begs the question of why Robert dropped his revolver in his coat pocket before setting out. This action also casts some doubt on John's later claim that the family was in fear that Robert might harm himself in his mental state. If so, why did he still have a gun?

At around three o'clock on the afternoon of March 16, as the brothers neared the spring, their eyes fell on the unwelcome form of E.Z.C. Judson. Without a word, Robert Porterfield drew his pistol and began firing wildly.

In fairness, Judson acted with considerable courage and restraint. He retreated from his adversary, pleading with him to talk about it, but Porterfield kept shooting. After two shots, Judson realized that his enemy meant to kill him, and he pulled his own pistol. He fired, hitting Porterfield above the right eye.

In the chaos that followed, Porterfield was carried home by his brother and others, while the unhurt Judson was arrested and taken to the county courthouse on the public square for arraignment. The scene inside was chaotic with a large, unruly crowd jostling for a view of the proceedings. The judge, after listening to the evidence, ordered Judson remanded to jail, but at that moment he was interrupted by an uproar. A chorus of spectators broke out, shouting, "Make way for John Porterfield! Let him kill Judson!" The crowd parted to reveal a grim-faced John, charging toward the bench with a pistol in hand.[42]

Judson broke for the back door, followed by Porterfield and several friends, who knocked down the sheriff and chased him, shooting as they went. At least ten shots were fired, one of which grazed Judson while others passed through his clothes. A rock knocked him down, but he got up and ran into the nearby City Hotel, where the mob cornered him on the second-floor balcony. With no other escape, the desperate fugitive leaped into space and

The grave of Robert Porterfield, killed by E.Z.C. Judson. *Author's photo.*

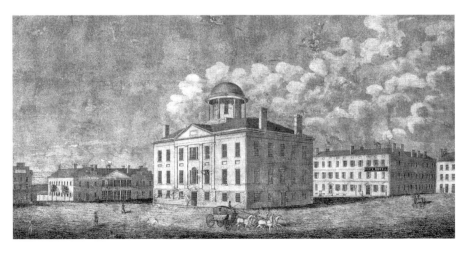

The public square. During Judson's arraignment, he ran from the courthouse (center) into the Nashville Inn (right) to escape his victim's vengeful brother. *Courtesy of the Hermitage.*

landed with a thud on the paving stones below. Unconscious and bleeding, he was carted away to jail.

Ominously, the crowd did not disperse once the excitement was over. Its numbers swelled steadily as darkness fell, until several thousand sullen men were milling around the courthouse, muttering angrily amongst themselves. It wasn't just riffraff either—the local press disapprovingly noted that the crowd contained "some of our most noted citizens."[43] Porterfield was very popular, and as reports arrived telling of his deteriorating condition, the mob's anger grew. Finally, at ten o'clock that night, the pent-up fury exploded.

Surging into the courthouse, the mob roared down the corridor and overpowered the jailer, who pleaded with them to disperse. Instead, the crowd threatened to kill him unless he handed over the keys. They surged into the cell, where Judson lay on his cot, badly bruised and in considerable pain. Then they manhandled him roughly into the public square.

Someone produced a rope, and one end was tied around his neck. The other end was thrown over a sign that arched over the sidewalk in front of a shop, and as the throng howled and laughed, the rope was pulled taut. Judson was yanked into the air, kicking desperately as he slowly strangled.

Without warning, the rope inexplicably snapped, and the victim fell to the sidewalk, choking for breath. Later, it was noted that someone had cut the rope halfway through before it was put around Judson's neck, probably by one of his friends in the crowd. As he was pulled to his feet and the mob prepared to string him up again, a voice from the darkness began to plead for sanity, yelling, "Take him back to jail; let the law have its course!"[44]

Remarkably, the mob did just that. The cry was taken up and grew louder, and thankfully the murderous rage began to subside. Several men hauled Judson to his feet and dragged him back to the courthouse, where they sheepishly handed him over to the jailer they had just threatened. Then, as if ashamed of their actions, the massive crowd slowly shrank as men headed home or off to a local saloon. Judson, battered and beaten but still alive, was thrown back onto the cot in his cell.

Around eleven o'clock that night, just about the time the crowd was dispersing, Robert Porterfield died of his wounds at his home. The following afternoon, his funeral took place at the First Presbyterian Church. Hundreds attended the service and accompanied his coffin to the City Cemetery, where he was interred next to the grave of his daughter. In a sad twist, the day of his funeral was also his son Frank's third birthday.

In the end, justice took its course, as unsatisfying as it may have been to many. No charges seem to have been filed against Judson—probably because

he fired back only after Porterfield had fired at him. One observer noted that "the friends of Porterfield will kill him the first opportunity that presents itself. He will never . . . go out of Nashville alive."[45] If such an attempt on his life were planned, it never came off, and as soon as he could limp, Judson left town. He returned to his native New York, where he quickly regained his old bombastic airs. He even wrote his own account for the *Knickerbocker* magazine, claiming unconvincingly that "as God is my judge, *I never wronged Porterfield*," and blamed his "enemies" for the attempted lynching. Just why several hundred of his personal foes had gathered in Nashville at that moment was left unexplained. The editor of the paper simply shook his head and wished that "Ned" would come out of it "a better and wiser man."[46] Time proved it a vain hope.

And what of the other party to the affair? Mary Porterfield seems to have been disowned by her husband's family, as well as the community at large. She was even expelled from the Baptist Church for her part in the affair. Soon afterward, she left the town entirely. Her son Frank was left with her in-laws, who raised him in their household.

Arlington National Cemetery. The central figure in the tragedy lies here today, a long way from the sorrows she knew in Nashville. *Library of Congress.*

Then, in 1855, a news article appeared in the New York City papers that would have startled the pious folks back in Nashville. On August 17, Mary Porterfield was reported to have married an army officer, Patrice de Janon.[47] The dashing groom was born in South America to French parents and had served as the "Master of the Sword" at West Point Military Academy. His native language was much in demand during the war with Mexico, and he was soon appointed professor of Spanish at the school. He served the army for the rest of his life, eventually rising to the rank of colonel. He and Mary had two children together.

By all accounts, Mary was devoted to her second husband. She stood by him solidly, once even confronting President Abraham Lincoln when he backed a motion to expel de Janon from West Point. At her death in 1891, she was granted an honor reserved exclusively for the families of those who serve their country: she was buried at Arlington National Cemetery. Her husband outlived her by a year, and today they lie side by side for eternity.

The Victorian era was not very forgiving to a woman's reputation, and once "dishonored," it was hard for her to escape the scandal. It is somehow comforting to think that Mary was able to rebuild her shattered life and find a second chance far away from the wagging tongues of the little town by the Cumberland.

5

BLOODY CHRISTMAS

The Civil War changed Nashville forever. The sleepy river town suddenly found itself a highly strategic point for the armies of both North and South. In 1862, the city became the first Confederate capital to fall to a Union occupying force, and for the next five years, Nashville would find itself under martial rule.

By the end of the conflict, the city had proven vital to the Union cause and served as a temporary home to thousands of troops, many of whom passed their off hours in search of the traditional recreation of soldiers. "Smoky Row" expanded tenfold, as prostitutes, gamblers and saloonkeepers did their best to relieve the young men of their extra cash.

The army and civil authorities managed to keep the lid on this simmering pot for most of the war, working together in an uneasy alliance to curb the worst of the violence and crime. Most notably, in 1863, prostitution was legalized. For the first time in history, the girls were allowed to practice their trade, provided they received a clean bill of health and paid a five-dollar licensing fee. Measures like this ensured that the men in the ranks would have their fun and come back healthy and ready to fight.

However, as the war wound down, the level of boredom increased. Young men far from home, without the usual restraints put on them by family or friends, began looking for mischief to get into between hours of drill and sentry duty. In addition, several thousand civilians hired by the government to work as teamsters, watchmen, laborers and factory workers filled barracks throughout town. Some were honorable and good workmen, but far too

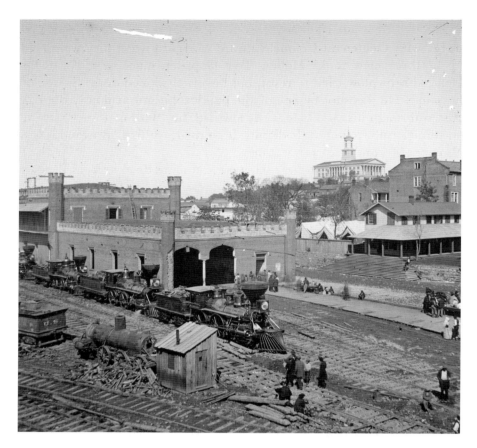

The Nashville & Chattanooga Depot, in the shadow of the state capitol, was a magnet for criminal activity during the war. *Library of Congress.*

many were what were known as "bummers"—shiftless types apt to look for trouble in their down time. The city was at a breaking point as the winter of 1865 began.

As the new holiday of Thanksgiving approached, the city papers began to report an alarming increase in violent crime. In addition to the usual drunken brawls, stabbings and shootings, a rash of highway robberies made travel on the highway hazardous in the extreme. From November 9 to 12, there were more than a dozen robberies on the roads around town. Edward Fitzgibbon was shot in the chin during one attempt, and an unoffending farmer named Richard Hamlet was shot and killed during another.

Even the most powerful were not safe. On November 10, General James P. Brownlow, adjutant general of Tennessee (and son of Governor

William G. Brownlow), was riding toward the town of Franklin in a buggy with Lieutenant Colonel Edward Maynard when they were held up by three men at the Hollow Tree Gap, ten miles from Nashville. General Brownlow tried to resist, but his pistol slipped down the leg of his pants. He was shot by one of the bandits, but miraculously the ball passed through his clothes without hurting him. Both men survived the encounter unhurt but with dignity thoroughly ruffled. Brownlow was also out $500 and mad as a wet hen.[48]

Almost certainly, one gang was not responsible for all these outrages, but they did have something in common. The perpetrators were wearing pieces of U.S.

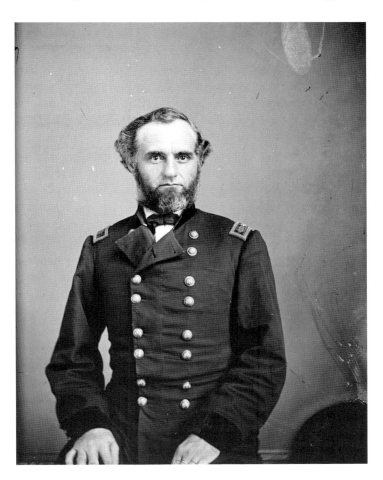

Major General Richard W. Johnson headed the court-martial that convicted the killers of William Heffernan in 1865. *Library of Congress.*

uniforms and were suspected to be off-duty soldiers or government workers. They were also trigger-happy to an alarming extent.

On November 15, Michael Davis was shot in the side by a bandit near the Penitentiary on Charlotte Pike. He made it to a house nearby but died the next day. In addition, the usual shootings and stabbings in and around "Smoky Row" and in the equally notorious "Hell's Half Acre" near the Chattanooga Railroad depot accounted for several more deaths and injuries. The situation was addressed in a humorous manner by the editor of the *Republican Banner*, who suggested a list of necessities for travelers around the city—ranging from brass knuckles, daggers and revolvers up to a "12 pounder howitzer brass cannon"—to be mounted in the coattails to fire at muggers.[49] The joke would sour only twenty-four hours later.

Nashville was recovering from the ravages of wartime that winter, and one of the key figures in the renovation of the city was public works contractor William Heffernan. A jovial Irishman and a leader of the local Catholic community, the forty-nine-year-old Heffernan was a beloved figure, admired by people of all walks of life as a generous and conscientious man.

On November 22—St. Cecilia's Day—he and his family attended a concert performance held to raise money for the recovery of St. Cecilia Academy, a Catholic school in the north of the city. Afterward, the party headed home in a carriage by way of Jefferson Street Pike. Joining Heffernan in the vehicle was his wife, Ellen; his daughter; and his son-in-law.

As they passed the government corral near Fort Gillem, a group of four surly looking men approached the vehicle. Heffernan's son-in-law, Michael J. Tracy, pulled his revolver and advised Heffernan to make ready in case of trouble. The kindly Heffernan told him not to worry. If there was trouble, he said he would talk them out of it.

Sure enough, the men darted forward, and one blocked their way, grabbing the horse by the bridle. The others pulled pistols and ordered the family to hand over their money. Heffernan attempted to reason with them, but in response two of the bandits grabbed him and pulled him from the carriage, beating him unmercifully with a "slung shot"—a leather bag full of lead shot. That's when Tracy opened fire.

One of the bandits was hit in the chest, and in a rage he fired blindly, grazing Mrs. Heffernan's face and striking her husband in the corner of the eye. The horse panicked and bolted, carrying Tracy and his wife several hundred yards away before he could regain control. When he returned, he found a tragic scene. The bandits were gone, and Heffernan lay dying in

the roadway with a bullet in his brain. His mother-in-law sat cradling her husband's head in her lap, crying hysterically.[50]

The shooting of such a loved public figure caused an immediate outcry of anger, and Mayor W. Matt Brown summoned his police force, ordering them to leave no stone unturned. Within hours, the wounded man was found lying on a bed in the back room of Matilda Harris's brothel on Jefferson Street. Tracy's bullet had cut a shallow groove in his chest and side, but it was more painful than dangerous. He was identified as George "Red" Craft, aged nineteen, a government teamster from Chili, New York, who worked at the nearby corral. He quickly confessed to the robbery but not the murder and "peached" on his accomplices, whom he named as James "Little Jimmy" Lysaught, a young Confederate veteran; James Perry, a watchman at a corral; and a deserter named Joseph A. Jones, alias Tom Carter. The accused were all hardened and dangerous men despite their youth. Lysaught, the youngest, was about eighteen years old. The eldest, Jones, was only twenty-two.

As word of the attack spread, the mood in town became decidedly grim. Heffernan lay dying at his residence, surrounded by his grief-stricken family. Dark whispers began to fill the streets, and it was feared that "Judge Lynch" would soon come for the suspects. In response, the government stepped in to keep the peace by appointing a "drumhead" court-martial to try the gang.

At 1:00 a.m. on Sunday, November 26, William Heffernan died. Hundreds attended his funeral at St. Mary's Church, then followed his hearse to his final resting place at the City Cemetery. Unusually, Heffernan was buried in the front half of the cemetery with the city's elite rather than in the traditionally segregated Catholic section in the rear. The charges against the young men were quickly revised to include murder.

The following day, Craft, Lysaught and Jones went on trial. Craft, the leader, proved a true hard case and arrogantly declared that he wasn't worried. "I'm not in the hands of your civil law now," he told one bystander. "The military will not harm me."[51] He was quite wrong. In fact, he had already made a powerful enemy in the ranks. General Brownlow, upon seeing him, identified Craft as the man who had robbed and nearly killed him two weeks earlier at Hollow Tree Gap.

The trio's defense was lame. All confessed that they were involved in the robbery but denied being the triggerman. The way they told it, all four scattered when the shot was fired, leaving nobody to shoot Heffernan. The star witness was Mr. Tracy, who tearfully broke down on the stand, asking the court to treat the accused "as if your own father had been killed."[52] The result was never in doubt. All three were found guilty.

The grave of William Heffernan in the Nashville City Cemetery, 2015. *Author's photo.*

Thomas Perry was arrested in Murfreesboro and tried a few days later. He was likewise found guilty. The findings were reviewed and upheld by General George H. Thomas, the commander of the district, and all four were sentenced to death by hanging. Their execution was scheduled for January 26, 1866.

The head of the military commission who tried the killers, General Richard W. Johnson, later remembered that the case marked a turning point. "From that time onward," he recalled, "lawlessness ceased."[53] The records don't bear him out. In fact, even while the trial was in progress, yet another shocking murder took place.

On the night of November 24, a hack left the city on the Franklin Pike, carrying revelers to attend a bridal "infair" being held south of town. Near John Thompson's Glen Leven plantation, a group of robbers jumped from behind a log and opened fire without warning. A ball struck a young man named John M. House in the chest, passing through his liver and lungs, inflicting a fatal wound. Just then, another carriage arrived on the scene carrying Confederate veteran Captain John Overton and a companion.

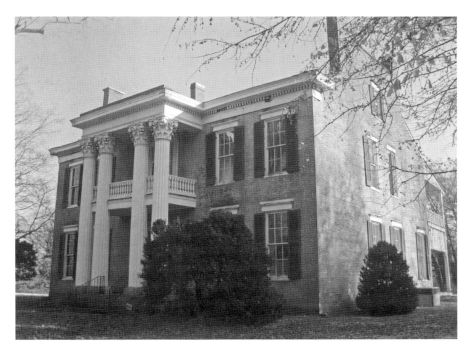

Glen Leven on Franklin Road. John House died here after being shot by robbers on the road nearby. *Author's photo.*

The two young men hauled out their revolvers and opened fire, chasing the culprits through the woods some distance before losing them. The wounded man was carried into the nearby Thompson house and made as comfortable as possible. Ironically, a young boy sent up the road to find surgical instruments to treat the victim was also held up by the same bandits and chased back to Thompson's place.[54]

John House was himself a Confederate veteran. Only nineteen years old, he had recently been released from a prisoner-of-war camp. He was a native of Knoxville and had come to Nashville only a short time before. He died that night at eleven o'clock, just hours before his beloved sister Ellen and his father arrived to care for him. The heartbroken family had him transported home to Knoxville for burial.[55]

The culprits in this case turned out to be members of a group of African Americans displaced by the war who were camping in the neighborhood along nearby Brown's Creek. Sixteen suspects were arrested by the sheriff the next day, four of whom were held for trial.

No sooner had this tragedy played out than yet another took place. At the small community of Scott's Hollow, just a few miles from Andrew Jackson's Hermitage, a group of robbers went on a rampage during the night of December 12. After robbing nearly a dozen farmers heading to market on the Lebanon Pike, the three hoodlums descended on a tollhouse and asked to come in and warm themselves by the fire. The toll keeper was a giant of a man named James T. Byram, "considerably over six feet in height, and weighing some two hundred and fifty pounds." He let the men in, confident that he could handle any trouble they offered.

As soon as they were inside, the men pulled pistols and demanded money. In response, Byram picked up a chair and raised it to club them with it. He wasn't fast enough, and all three opened fire. Shot five times, Byram collapsed on his bed in front of the horrified eyes of his three children.[56]

Byram's wife, Sarah, rushed into the room in shock. The ringleader pointed his pistol at her before throwing her roughly against the dresser standing along the wall. She managed to push past him and fetch help, but it was too late to help her husband. The killers had disappeared into the night, but they had made a mistake: Sarah had recognized the leader.

Two weeks before, she recalled, her husband had gotten into a fight with a shifty teamster named James Greene, who refused to pay the toll, calling Byram a "damned liar" when he demanded payment. Byram had thoroughly thrashed Greene in a fistfight and told him to leave his house. Later, it was revealed that Greene had stewed over his humiliation at the

hands of the toll keeper and swore he would kill the whole family in revenge, vowing to "burn their bodies with the house." It seems that Sarah escaped before Greene could carry out his threat.[57]

Three days before Christmas, Greene was apprehended after running his wagon against another vehicle on Nashville's public square. He was quickly identified by the widow Byram as her husband's killer and held for trial. In June 1866, James Greene was found guilty of the murder and sentenced to a long stretch in the State Penitentiary at Nashville.

As the new year dawned, the war-weary town prepared for the execution of William Heffernan's murderers. It had been more than twelve years since there had been a public hanging (as opposed to the private executions by the military), and a morbid excitement was in the air.

Major General George H. Thomas, commander of U.S. forces in Tennessee, approved the sentences of the Heffernan killers. *Library of Congress.*

The prisoners themselves were unrepentant, made off-color jokes and teased one another whenever visitors were allowed to see them. The youngest, baby-faced Jimmy Lysaught, turned out to be one of the toughest. When a reporter asked him a question that he didn't wish to answer, his response was: "I'll tell you about that on the gallows."[58]

Only Thomas Perry had family to visit him, receiving his brother several times. The others had no friends other than the penitentiary staff, who treated them very kindly during their stay. About the only desire they all expressed was for a chance to get even with their accusers. All in all, a witness remarked, the youngsters "seemed to possess the nerves of veteran soldiers, with the moral depravity of octogenarian criminals."[59]

After making their farewells on the morning of January 26, 1866, the four were seated in an army wagon drawn by four white horses, in which were four

plain wooden coffins. They were carried to the gallows, which was erected on a hill between Fort Dan McCook and Rokeby, the former home of Judge O.B. Hayes (about where RCA Studio B stands today). Approximately ten to fifteen thousand spectators gathered to see their last moments, including, as one reporter disapprovingly sniffed, "a lady standing close to the scaffold."[60]

The condemned made a few remarks, mainly praising the warden for his kindness before the hoods were drawn over their heads. After a final prayer by Father J.R. Bergrath, the signal was given, and the executioner cut a rope with an axe, springing the trapdoor beneath them.

Lysaught had joked earlier that he was so small that he worried he wouldn't die easily. Ironically, he was the only one who did. Perry, Knight and Craft "died hard," strangling slowly at the end of their ropes, kicking and struggling for several minutes while "the white head caps were moistened by froth from the lips of the dying men."[61] Perry's body was turned over to his family for burial. The other three were swiftly disposed of in unmarked graves.

Sadly, if it was intended as a deterrent to crime, the hanging was a failure. On the very day they died, there were two riots in "Smoky Row" in which two civilians and a soldier were wounded and several others received cuts and bruises, along with the usual fights and robberies. However, the deaths of the four marked at least a symbolic turning point. The winter of 1865 was the low ebb in Nashville's long and painful occupation. Afterward, criminals faced stiffer resistance and better cooperation from both the military and civilians, who organized citizens' patrols to help police the rougher areas.

The situation definitely improved, but not until the end of military occupation the following year and the exodus of the soldiers and the attendant gamblers, prostitutes and con artists who preyed on them would Nashville begin to see calm restored. However, the city would never truly be the same.

6

ROCK CITY BLUES

Caesar Augustus once said, "I found Rome a city of bricks, and left it a city of marble." Something similar can be said of Nashville following the Civil War. Reconstruction led to rapid growth and an influx of wealth that transformed the very fabric of the landscape; by 1890, the town of brick had become a town of stone.

New schools—like Vanderbilt and Fisk—were born, and Nashville became known as "the Athens of the South" for its educational opportunities. There was a resurgence in trade as the nation rebuilt itself, and much of the necessary materiel flowed through the city's rail yards and wharves. As the new century approached, downtown began to beam under the bright glow of electric lights, and a tangled web of telephone cables crisscrossed the streets. Architects reshaped the city, building Victorian masterpieces such as the Customs House and Union Station—new stone monuments to trade and enterprise. Even the brand-new Tennessee State Prison, opened in 1898, was a state-of-the-art facility, imposing in design and built of the limestone that gave the community its nickname: "the Rock City."

However, as always, more money meant more problems. Passions ran high, fueled by greed, lust, pride and all the age-old motives for doing harm to others. And liquor flowed freely, fanning the flames. By 1900, Nashville is thought to have had over two hundred licensed saloons, and who knows how many unlicensed "blind pigs" in dark alleys across town. "Smoky Row" faded away, replaced by "Hell's Half Acre" and "Black Bottom" as the "oldest profession" continued to cater to all walks of life.

In another way, the town had grown up. During the years between the Civil War and World War I, Nashville also saw the first stirrings of modern "big city" crime, as some of the following stories attest.

A TOXIC RELATIONSHIP

At nine o'clock on the evening of November 22, 1884, an African American hack driver named Prince Graham (also known as Prince Greer) put up his vehicle and horses and entered the small rented house he shared with his common-law wife, Mollie, at 277 Lincoln Alley. Two hours later, he was dead.

Initially, it was thought that he had died from "apoplexy," or a stroke. But during the coroner's inquest, some disturbing facts came to light. Graham, as it turned out, was only forty and in excellent health, according to the doctors who examined him. There were no signs of either heart disease or apoplexy. In fact, the signs pointed to poisoning by either "prussic acid" (liquid cyanide) or belladonna. They theorized that the poison was administered either in Graham's coffee or a small pint flask of whiskey found in the room.

Witness after witness testified that the Graham home was no love nest. Fights were frequent and vocal. Just the Thursday before, Mollie had screamed at her husband loud enough for the whole neighborhood to hear that she would "land him in hell by Saturday night!" In fact, the day he died—that very Saturday—Graham had confided to his brother-in-law, Sam Mitchell, that "me and my old gal's having a heap of trouble now."[62] Mitchell told him that he ought to leave her or "there'll be a funeral and you'll be to bury." It was the old story. Graham said he knew it, but "in spite of all that, he loved her."[63]

Mollie Graham's story was that she lovingly tended to her ailing husband, who suddenly died after taking a turn for the worse. Nearly everything she said was refuted by other witnesses, and she was forced to admit that she could occasionally be of a "fractious" nature. She was quite a young woman—about half the age of her husband. Even more startling in that racially charged age, the witnesses noted that Mollie was "generally believed . . . to be a white woman," although she was in reality of mixed descent. It was quite clear to all involved that the Grahams had a most unconventional marriage for the time and place.

When lab tests showed indications of poisoning, Mollie was arrested and jailed until her examination before the grand jury. Prince was quietly buried

Like this man, Prince Greer learned the embalmer's trade while working on soldiers from the battlefields of the Civil War. *Library of Congress.*

under his original name of Greer a few days later, and the case was quickly forgotten by all but those who lived on Lincoln Alley. In death, Prince was remembered only as a hack driver, "generally popular and very well known." However, in his youth, he had been much more than just another cab driver. He had been a pioneer in African American labor—albeit in an odd way.

Born into slavery in South Carolina around 1840, Prince went to war with his master, a Confederate officer from Texas who was killed at Fort Donelson. The slain officer was embalmed and sent back to Texas by Nashville's government undertaker, William R. Cornelius, who ran a massive operation interring the dead from the war. By war's end, his firm had handled nearly twenty thousand burials of Union troops and Confederate prisoners.

When his master's body went to Texas, Prince understandably decided not to accompany it. Taking the last name Greer, he became a fixture around the office, running errands for Cornelius and company. He was also in the way. Not really knowing what to do with him, Cornelius decided to scare him off by offering to teach him the mortuary business. To his surprise, Prince rolled up his sleeves and took to the new trade without batting an eye. "He became himself an expert and kept on at work embalming . . . and was very successful," Cornelius remembered. "It was but a short time before he could raise the artery as quickly as any one, and was always careful, always of course coming to me in a critical case."[64] As far as is known, Prince Greer was the first African American embalmer in U.S. history.

After the war, Greer drifted out of the undertaking business, working briefly as a miller before settling down as a hack driver and using the name Graham, under which he died. Sadly, he is as forgotten in death as in life. Today, he rests in the badly neglected Mount Ararat Cemetery on Elm Hill Pike, the first African American burying ground in Nashville, all but abandoned and choked with weeds and trash. His gravestone—along with many others—has long since been lost.

Greer (or Graham) is buried at Mount Ararat, Nashville's first African American cemetery on Elm Hill Pike. The site was badly neglected as of 2016. *Author's photo.*

And Mollie? The grand jury decided there was insufficient evidence for an indictment, and she was released. With her health broken by her stay in jail, she was taken in by the Nashville Medical College, where she was nursed back to health by a young intern named Dr. Woods. Woods took pity on her and gave her a job at the hospital—as a cook. In hindsight, it wasn't the best idea.

Soon after, Woods reported her for a small infraction of the institution's rules, and Mollie reacted in a "fractious" manner, cursing and screaming. She swore to others that she would get even with him.

The day after that episode, Mollie cooked a dish of spring peas, which were Dr. Woods's favorite. For some reason, Woods and the other interns passed on the peas when they stopped in for lunch. However, six other hospital employees ate the dish with gusto—and promptly keeled over in agony. Following heroic exertions by the doctors, all six eventually pulled through, but their symptoms suggested that the peas had been topped with arsenic.[65]

Arrested again and charged with assault, she was brought before the grand jury, which was already in session. On June 30, 1885, they met once more, and once more they failed to indict. Perhaps her callous protestation that "the peas were merely sour" was true.[66] At any rate, she was soon released, and from that point all trace of her is lost.

A MATTER OF HONOR

Sex and violence always seem to go hand in hand. As Nashville was just beginning to recover from the Civil War, polite society would be rocked by a rude scandal involving seduction and murder. At its heart was a member of one of the oldest and most respectable families in town.

It began with a racy news article that appeared in the *Louisville Courier* about some goings-on at the local hotels. On October 13, 1866, a gentleman accompanied by a lady with a small child asked to take side-by-side rooms at the National Hotel. All seemed proper until the hotel detective noted that the man and woman were not exactly complying with hotel policy as it regarded unmarried couples. The pair was promptly evicted and moved to the Louisville Hotel, where they pulled the same shenanigans. Someone ratted them out, and when the staff found the pair in bed together, they were sent packing. The lady was described only as a "widow, belonging to a most excellent family," while the man was identified by name. He was Charles

Henry Wheelwright Bent, a thirty-one-year-old agent for the Associated Press, and—as the paper gleefully pointed out—"a married man, and the head of an interesting family," with two children of his own.

Bent immediately took to the press to defend himself, denying the truth of the article, calling the author "a liar and a swindler."[67] Unfortunately, nobody seems to have believed him. Nashville and Louisville were both small towns at the time, and it wasn't long before folks put two and two together and identified the "widow" as Mrs. Mary McGavock De Zevallos.

In fact, Mary was a widow twice over. Her first husband was Hugh L.W. McGavock, a member of one of the most prominent families in Nashville. He died in 1853, and four years later, she married again, this time to Edward P. De Zevallos, a professor of language at the University of Nashville. Sadly, he, too, died after only a year of marriage. She was left with a child from each marriage.

Sometime during the war years, Mrs. De Zevallos met the dashing Charles Bent. It seems they were brought together by their fondness for music, as both were accomplished singers and members of musical societies. On several occasions, the local press innocently mentioned them singing together at public concerts, her soprano voice complementing his fine tenor. Suspicion grew that a deeper intimacy was developing between them, and the scandal sheet article seemed to confirm it.

The talk was especially galling to Mary's eldest son. Hugh Frank McGavock was just twenty-one at the time, a quiet, industrious and well-respected young man. Understandably, the gossip about his mother was more than he could bear, so despite Bent's denials, the young man confronted him on the morning of October 22. In a heated exchange, he told Bent that the next time they met, he intended to kill him. Afterward, McGavock secured a small .36-caliber Manhattan revolver and went hunting for his quarry.

Around 1:00 p.m., Bent left Cone's Bookstore on Cherry Street (now Fourth Avenue) after buying the latest *Police Gazette*. Along with a friend named E.P. Johnson, he proceeded up the street. Neither spied McGavock, who was watching them from the door of an icehouse across from the store. Shoving Bent backward to clear Johnson from the line of fire, the angry young man pulled his pistol and fired from only three feet away.

The first ball passed through Bent's upper left arm and lodged in his lung. Remarkably, Bent made no move to retaliate—he just grabbed the wounded arm and began slowly walking away from his attacker. As bystanders called out to stop, McGavock raised the pistol again. The cap popped, and the piece misfired. Cocking it again, he took careful aim and fired.

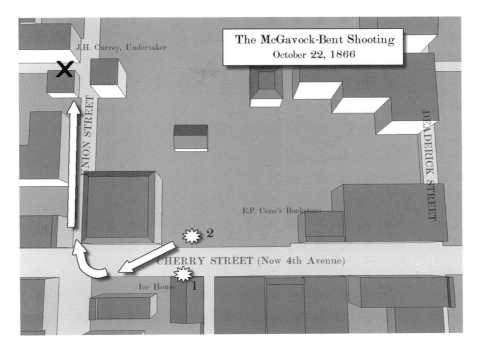

Hugh McGavock (1) shot Charles Bent (2) outside Cone's bookstore and pursued him until he fell in an alley on Church Street (X). *Author's diagram.*

The second ball hit Bent as he was stepping onto the sidewalk across the street, passing though his right shoulder blade and windpipe and emerging near his breastbone. Bent finally began to run, staggering jerkily up Cherry Street while he weakly begged Hugh not to shoot him again. By that time, it was too late—either wound would have eventually proved fatal.

Bent turned up Union and staggered to the mouth of an alley a short way up the street, where he finally collapsed. Coincidentally, his head came to rest only three feet from the wall of an undertaker's parlor. A crowd quickly gathered at the scene and stood gawking at the bloody spectacle until his body was taken into the establishment and laid on a bier with a handkerchief over his bloody face.[68]

Hugh stood quietly by until a policeman approached. When the officer told him he was under arrest, he blinked with apparently genuine surprise and asked why as he surrendered his pistol. As he was carried to jail, a coroner's jury was summoned to examine Bent's body. They were amazed to find that the deceased had two guns on him: a .22 Smith & Wesson revolver and a Sharp's four-barrel pistol. Bent had made no move to draw either

weapon during the attack, whether it was due to shock or some other cause. His passive actions during the shooting were "perfectly unaccountable" to witnesses.[69] After the examination, a runner was sent to gently break the news of his death to his wife, and his body was carried to their home at 29 South High Street (now Sixth Avenue).

McGavock eventually stood trial in the criminal court but was acquitted and released, returning to a quiet and respectable life. He married in 1889, but the match would last only a few months. After a long struggle with consumption, he died on New Year's Eve of the same year at the age of forty-five.

BIRD IN A GILDED CAGE

Just past six o'clock on the sticky warm evening of July 5, 1883, the tranquility of one of the city's most respectable neighborhoods was shattered by a gunshot and a woman's scream. Concerned passersby soon descended on the door of 9½ Summer Street (now Fifth Avenue) and burst inside. They were greeted by a weird tableau.

A woman dressed in a light white sack dress sat in a rocking chair facing the door. A bloodstain the size of a silver dollar was visible on the left side of her chest, and under the table beside her lay a .38-caliber Smith & Wesson "self-cocker" revolver. Over her, weaving slightly, loomed a gray-haired man dressed in a long black coat. The woman raised her hand feebly and screamed, "For God's sake, come here! I am shot through the heart!"[70]

A doctor and a dentist in the crowd forced their way into the room and began a frantic attempt to save the woman's life. Meanwhile, the man in black made his way to a nearby bed and threw himself facedown on it, showing little concern for the drama occurring a few feet away.

The doctors repeatedly asked her what had happened, but she was already in a state of collapse and either wouldn't or couldn't answer. They carried her to the bed, where they placed her alongside the motionless stranger, who murmured that she had shot herself.

As the doctors removed her bloodstained corset, they found a letter secreted inside. At first, it was hoped this would offer some clue to what had happened, but it turned out to be a rather mundane letter to "My dear Mamma" about family news and recent events. It was signed, "Louisa." A stimulant was injected into her arm to try to revive her, but the only result

Fifth (formerly Summer) and Church Streets, circa 1910. A few doors up on the left was the apartment where Birdie Patterson met her mysterious end. *Author's collection.*

was a groan and a gurgled mumble that sounded like "murder" to some in the room and "mercy" to others.[71] Within forty minutes, the woman was dead.

The police soon arrived and began questioning witnesses. They established that the dead woman had a rather murky reputation in town and went by several aliases. She usually used the first name Louisa, although she went by several last names. Around the neighborhood, most folks knew her by her rather colorful nickname: "Birdie" Patterson. As investigators dug deeper into her background, a rather scandalous story began to take shape.

Birdie was what was then known as a "kept woman." Born in Atlanta, she was known there as Lottie Ross and was well known in police circles. After leaving an unhappy marriage, she drifted through the South seeking boyfriends who supported her for a while before she moved on. Birdie moved through a dark and seedy world. Already, she had testified as a witness in an Atlanta murder case in 1879, when Sam Hill killed John Simmons for seducing his wife. She had also been treated for an unspecified "disease," the nature of which seems obvious.

Despite her misfortunes, Birdie retained an air of respectability about her. Dark haired, with a porcelain complexion, she was remembered as "fresh and rosy as a May morning,"[72] and it was said that few who met her would

have suspected her of impropriety. Her roving life had come to an end at the age of twenty-eight. Friendless and alone in a strange town, she was buried under the name Louisa P. Nicholson in a remote section of Mount Olivet Cemetery. Her grave was never marked.

The mystery man was identified as William L. Boyd, aged sixty, a widower and longtime resident of Nashville. A heavy drinker (he was readily identified as a regular by the bartender at the nearby Maxwell House hotel), Boyd sometimes passed as "Birdie's" uncle, but he insisted she was just a "young friend" of his. However, in an unguarded moment, Boyd referred to her as "baby," leaving little question about the nature of their friendship.

Boyd was extremely drunk but insisted that Louisa had shot herself. The doctors, however, failed to find any powder stains on her white dress, and Boyd was arrested and charged with murder. The inquest found that the ball had passed completely through her and the rocking chair, nicking the heart and passing through a lung. The path of the projectile ranged inward and downward—a trajectory that suggested Boyd had shot her while she was seated.

His trial was held in September, and from the beginning the evidence was mainly circumstantial. It was evident that Birdie and Boyd were both heavy drinkers and given to quarreling. Letters found in her room proved that Boyd wasn't the only string to her bow, and it came out that the night before she had gone to an Independence Day ball without him after a heated argument. Jealousy and abuse was very much part of their relationship.

Science tended to back up the murder theory. The angle of the bullet made it unlikely that Birdie could have shot herself. And in an early example of forensic testing, a specialist stated that he had fired a pistol into a patch of cloth from different ranges and believed the victim was shot from a distance of around three feet. He also burned himself and said he didn't want to repeat the experiment.

On the other hand, witnesses said she was often depressed and had threatened suicide before. There was talk of unrequited love for a former "protector." It was also noted that in her dying declaration, she said she'd been shot—but at no time did she directly say Boyd had shot her.

Boyd maintained that it was suicide or an accident, although he admitted he was so drunk that he didn't fully remember what had happened. In the end, the jury decided against him. Boyd was found guilty of second-degree murder and sentenced to fifteen years in prison.

What followed was one of the most epic legal battles in the city's history. Boyd's lawyers filed their appeals, and the Supreme Court took the case.

After finding improper procedure in the discharge of a juror, the verdict was thrown out, and a new trial was ordered. In September 1885, Boyd got his (second) day in court.

Once more, the evidence was weighed, and this time the outcome was a bit different. Boyd was again found guilty of second-degree murder and this time got ten years in prison. A second appeal was then made to the Supreme Court, and once more it found in favor of the defendant, citing improper instructions to the jury. The second verdict was thrown out, and a third trial was ordered.

William L. Boyd would not live to see it. On Halloween night of 1888, the newspapers quietly announced that he had died at his home on Cedar Street.[73] With little public fanfare, he was buried a few days later in Mount Olivet Cemetery—a stone's throw from his ill-fated mistress, Birdie Patterson. Today, both rest there in peace, the scandal that followed them to the grave long forgotten.

CAPITOL CRIME

Politics in Tennessee have always been rough-and-tumble, and gunplay is not exactly unheard of. Since its construction in 1845, the hallowed halls of the Tennessee State Capitol Building have several times echoed to the roar of shots fired in anger. However, the only man ever killed within its walls was the accidental victim of a bullet meant for someone else.

It all started with a squabble over authority between John W. Kirk, state superintendent of prisons, and Warden Andrew B. Vaughn of the Coal Creek prison mines. The quarrel came to a head when Vaughn fired a guard named O.B. Paxton, whom Kirk had hired. The superintendent reinstated the guard and confronted Vaughn, reminding him to whom he owed his own job. Vaughn haughtily replied that he didn't feel he owed Kirk anything. In Tennessee in 1895, the prisons ran on patronage, and Kirk was incensed at Vaughn's attitude.

On May 30, 1895, Kirk called Vaughn into his office at the capitol, and a heated exchange ensued. In the end, Kirk bluntly informed his subordinate that, in the future, only the superintendent had the final say-so about who was hired or fired, and Vaughn left the office in a huff. A rumor went around that Kirk was seriously considering removing Vaughn from his position. If so, he never got the chance.

The Tennessee State Capitol on Cedar Street (now Charlotte Avenue) in 1901, six years after John W. Kirk was killed. *Library of Congress.*

Minutes later, a fuming Vaughn stepped out of the state treasurer's office and saw O.B. Paxton standing in the corridor. After accusing the guard of telling Kirk a "damn lie" about his dismissal, Vaughn called him every name in his salty vocabulary. Not satisfied, he began beating the guard with his walking stick and landed several licks on Paxton's arm before he was pulled off by bystanders. Among those intervening in the fight was J.T. Davis, chairman of the Democratic Executive Committee in Marshall County, who punched Vaughn in the face to stop him. Davis and the battered Paxton went into the office of Governor Peter Turney, while Vaughn and Kirk went into the treasurer's office to cool down.

Things might have blown over but for one last childish taunt. Vaughn began asking for his walking stick, which had disappeared in the mêlée. After a moment, Davis entered the treasurer's office with Vaughn's property in hand.

"Is this your stick?" he asked.

"Yes, damn you, and I want it!" was the sharp response.

Davis sneered back, "Don't be in such a hurry about it, or maybe you won't get it."[74]

At that, Vaughn called him a "damn son of a bitch" and made a grab. Davis jerked it away, and the two grown men engaged in a ludicrous game of "keep away" among the treasurer's office furniture. Blind with rage, Vaughn finally grabbed the stick, and at the same time he drew a revolver from his pocket. The wide-eyed committeeman ran for the door just as Vaughn opened fire.

Two shots were fired in the office and two more as Davis fled down the corridor, but the man from Marshall County made it out of the building unharmed. As Vaughn returned to the scene, the stunned crowd told him the awful truth: one of his wild shots had hit John W. Kirk, inflicting a critical wound. As people rushed to aid the fallen superintendent, Comptroller James A. Harris suggested that Vaughn would hang "higher than Haman" for the shooting. Vaughn turned on him, and bystanders managed to pull the still-smoking pistol from his hand before the shooting became a double tragedy.[75]

Kirk was rushed to City Hospital, where he drifted in and out of consciousness. The bullet had struck him behind the left ear and lodged somewhere in his brain, and doctors had no hope for his recovery. He was paralyzed on the left side but remained able to respond to questions in monosyllables. Occasionally, he asked what was hurting him. He lived long enough for his wife to arrive from their home in Henderson before he died of his wound at a quarter past midnight on June 1, 1895. His body was returned to his native Chester County for burial. The funeral was well attended, and he was laid to rest under a poignant epitaph that read: "At evening time, it shall be light."

The constituency of Chester County was, needless to say, outraged. Given the heated exchange just minutes earlier, many questioned whether Vaughn had really "accidentally" shot his boss. An investigation was demanded, and the warden was summoned back to the capitol from his home in Franklin, Tennessee. Curiously, for a man who had athletically vaulted over Kirk's fallen body to get a second shot at Davis, he was now reported to be lying at death's door with a fractured skull and a concussion suffered in the fight. He had also "lawyered up," retaining several high-powered attorneys to represent him. Despite his three doctors' notes, one suspects there was another reason for his reluctance to return.[76]

As might be expected, the case finally ended in anticlimax. After a long series of conflicting evidence, vilification of witnesses and downright

puzzling instructions from the judge, the jury returned its verdict on April 15, 1896. Andrew B. Vaughn was not guilty of murder. The court erupted in applause and congratulations, and one juror later said that though they deliberated two days, the verdict "could have been reached without the jury leaving their seats."[77]

In time, the tragedy was forgotten. Vaughn continued his career in the prisons for more than a decade afterward. As for his unintentional victim, the state legislature adopted a tribute of respect to the fallen Kirk, but like many similar gestures, it was soon forgotten. Today, there is little to mark the memory of the man who was "shot by mistake" in the capitol building.

THE HEADLESS HORROR

J anuary 18, 1886, was a typical winter day: cold, wet and miserable. The melting snow and resulting mud had turned Belleville Street into a sloppy morass, and locals took to cutting across the open lot next to Mason's leather tannery to spare their shoes. Eugene Hall was on his way to work at the Nashville & Chattanooga rail yards, walking over the long pile of tan bark, muck and trash piled against the rock wall, when he noticed something peculiar. At first, it didn't register. Then, after a short distance, he did a double take when he realized what he had seen: a human arm stuck grotesquely out of the rubbish, a rope tied around the wrist.

By sunset, a crowd had assembled at the scene, and by lantern light in the frigid darkness, they raked through the muck with shovels. Soon, they had uncovered another arm, a leg and a human torso cut in half. The rough cut marks indicated that the body had been chopped up with an axe. The flesh was discolored from the chemicals in the tan bark, and some debate was carried on about whether the body belonged to a white or a black man. Frayed ropes around the wrists and torso showed that he had been tied before being killed. There was no sign of the head and no way of identifying the body.

Rumors ran rampant through the crowd. Maybe the body was that of a lover killed by a jealous husband. Or perhaps it was a case of body snatching from a nearby graveyard. The crowd was in an ugly mood, and one voice was heard to say that if the culprit could be found, "the stake is too little for him!"[78] The sensational mystery soon captivated the press, and one of

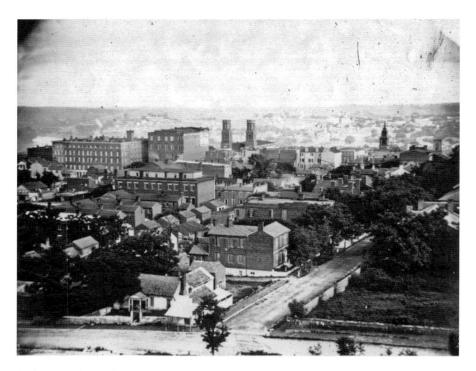

A view over the rooftops of Nashville around 1880. One of the first "media crimes" was about to shake the city's tranquility. *Courtesy Metro Nashville Archives.*

Nashville's first real "media frenzies" followed, as reporters vied for scoops from the authorities. The *Nashville American* led the way in sensationalizing the story and soon dubbed the mystery "The Headless Horror."

The first task for the authorities was to identify the victim. Missing persons reports were examined from as far away as Cincinnati and Montreal, but one by one, these leads dried up as the missing men were accounted for. Tips of all sorts came in. A medium even announced that he had contacted the dead man at a séance. The spirit revealed that he was killed by "a negro brakeman on one of the railroads." However, as the newspapers snorted, the spirit thought it "too much trouble to recollect his own name."[79] The authorities made little progress for several days while they searched for the missing head.

West of town, in the rural district along Harding Pike, a bizarre and seemingly unconnected incident was progressing. It started on the night of November 9, 1885, when four men came to the door of an African American farmer named Frank Arnold. The men were his neighbors: Ben

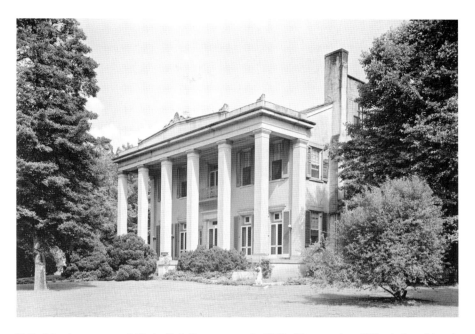

Belle Meade was one of Nashville's finest estates in 1885. The murder of Frank Arnold took place only a short distance away. *Library of Congress.*

Brown, Simon Fox and Nelson Joslin, along with Joslin's son Foster. They invited Arnold to go 'possum hunting with them, something they'd done several times before. Arnold accepted and told Norris "Noshey" Lane, who lived with him, to put some potatoes on the fire so he'd have something to eat when he came back. That was the last time anybody saw Frank Arnold.

Within two days, Ben Brown had told young Lane that his "Uncle Frank" had suddenly decided to visit family in Kentucky, but he was expected back about the first of March. Then, Brown moved into Arnold's vacant house, telling curious neighbors that he had mortgaged the place for a loan of $250 from the absent man. When Brown was spotted in the old man's wagon and seen "improving" his house, suspicion began to grow. Then the body was found in town, and many began openly accusing Brown of murder.

Brown bore an unsavory reputation. He had lived in town since just after the war, when he served with the Seventeenth U.S. Colored Infantry and fought at the Battle of Nashville. His war record was far from glorious, though. Old comrades claimed that during the war, he had murdered three members of his own company and robbed several others. Although the

claims can't be verified, they give a hint of the dread some people felt when Ben Brown passed by.[80]

Despite the suspicion, Ben remained cool and even produced a bill signed by Arnold transferring the property to him. However, Captain Martin Kerrigan of the police was not convinced and eventually arrested Bill Brown, who was related to Ben by marriage. The authorities leaned on their prisoner, putting him through the "third degree" and threatening him with hanging if they caught him in a lie. Terrified, Bill Brown broke down and launched into a gruesome confession.

The body, he said, was Arnold's. On the night he disappeared, the conspirators had led the old man just a short distance from his house into a thicket near the railroad. There, he said, Simon Fox had shot him in the head while Ben Brown stabbed him in the chest and beat him with an iron bar. The body was taken to the stable on Frank Arnold's place the next day in a spring wagon, and there it was chopped into pieces. Brown and the Joslins drove the pieces to town and buried them at the tanning yard. Meanwhile, Simon Fox dissected the head and removed his bullets from within it before hiding it near the scene of the crime.

A dragnet went out and arrested the Joslins and Simon Fox, while two officers escorted Bill Brown to the Arnold house. After a long search of the place, Brown finally knocked over a bee gum tree, in the top of which was what the papers referred to as the "Horrible Head." The parts were reunited at Combs's undertaking parlor, and a coroner's jury was finally able to identify them as the earthly remains of Frank Arnold.

The same night, a party of policemen was returning empty-handed after another search for the slippery Ben Brown when they spotted a man lurking by the rock wall near General W.H. Jackson's Belle Meade plantation. At gunpoint, they confronted him, and after striking a match and peering into his face, they identified him as the badly wanted suspect. Told he was under arrest, Ben replied, "I was expecting it." He also claimed that, coincidentally, he had been on his way to turn himself in at the very moment they found him.

The trial of Ben Brown for murder opened on March 1, 1886, and for the next five days, the city was captivated. Young "Noshey" Lane, only sixteen years old, proved the most damning witness against the accused. The youth referred to Arnold as his uncle but wasn't related by blood. The old man had taken him in, and Lane lived on the place almost as a foster son. His testimony proved that the last people seen with his "Uncle Frank" were Brown, the Joslins and Simon Fox and that no trace of him had turned up after their late-night hunting party.[81]

Ben Brown in a woodcut from a photo taken at the time of his arrest for "The Headless Horror." *Author's collection.*

Other witnesses proved the bill of sale was a forgery. Ben Brown, along with a man he called Frank Arnold, had approached J.J. Carey and asked him to draw it up several days after the old man had vanished and back date it to November 10. However, Carey said the "Frank Arnold" who had been with Brown did not resemble the deceased.

The defense scored a few points by punching some holes in Bill Brown's testimony. His story seemed to shift in terms of who had been present and who had actually struck the fatal blows. Likewise, the physical evidence didn't seem to match his account of what happened. Nowhere were the ropes around Arnold's wrists explained, nor was there evidence of any gunshot wounds to the victim. Most likely, Bill was distancing himself from his own involvement in the crime. Two cellmates later testified that Bill had

said he would let "a hundred negroes' necks be broke to save" his own—an allegation he strenuously denied.[82]

After two days of deliberation, the jury returned its verdict: guilty of murder in the first degree. Throughout the trial, Brown had sat calmly near his wife and child, showing little emotion. He took the announcement of the verdict with the same stoicism, leading the press to interpret him as particularly cold-blooded. He was sentenced to hang.

A legal battle ensued, as might be expected, and the case went all the way to the state Supreme Court. During the lengthy appeal process, Ben remained as stoic as ever. He passed his days in his cell, where he could often be seen sitting on his bunk reading from a small book. An official later

Simon Fox died in prison after his conviction for complicity in the murder. *Author's collection.*

remarked, "If I had that man's face I'd be the greatest poker player in America."[83] In February 1887, the Supreme Court upheld the verdict, and Ben Brown's execution was scheduled for the coming spring.

Meanwhile, Brown's co-conspirators were also tried. Simon Fox was given twenty years in the state penitentiary for his part in the crime, but he barely made it one year. On April 8, 1887, he died of consumption in the prison hospital. When told of his death, Ben Brown gave his usual calm smile and remarked, "Well, I hope he has made peace with his God."[84]

One week later, on April 15, Ben Brown took his final walk from his cell to the gallows in the jail yard. The hanging was a private affair, with only fifty witnesses present, though several hundred milled about on the sidewalk outside. After prayers and a hymn, Ben made a short speech in which he proclaimed his innocence. He stated that he looked forward to heaven, calling the gallows his train depot and declaring, "I only need to get my ticket."[85] All in all, his apparent sincerity impressed even the cynical reporters who witnessed it. At 11:17 a.m., the rope was cut, and Brown dropped through the trap. He died hard, kicking his slippers from his feet as he convulsed, but in ten minutes he was pronounced dead and cut down. His body was turned over to his family for interment in Mount Ararat Cemetery.

The excitement about the case seemed to die along with him. Bill Brown crowed in triumph after the deaths of Fox and Ben Brown. He claimed that he'd had a dream that all the others would die before him and that he would walk free. The second part came true, anyway. Despite the suspicion that Bill was more involved than he claimed, the case against him and the two Joslins was eventually dropped, and they were released in September, promising to "keep still" from that point on.[86] They were soon lost to public sight, their exact involvement in the Arnold murder unclear even to this day.

That was the end of the story for Frank Arnold and his alleged killer, Ben Brown. Or was it? There were two eerie postscripts to this twisted tale of murder. The first involved the old Arnold farm on Harding Pike. After the old man's murder, the place fell abandoned, as neighborhood rumor had it that the ghost of its former owner still hovered nearby. Folks avoided it after dark, and for a year it stood derelict as a grim reminder of the tragedy. Then, one night in February 1888, it mysteriously burned to the ground, taking all its terrible memories with it.

Even more startling was the story that made the rounds a few days later. The turnkey at the city jail was making his rounds around midnight on February 26, when he passed the "death cell" where Ben Brown had spent his last hours. In the dim circle of light thrown by his lantern, he spotted

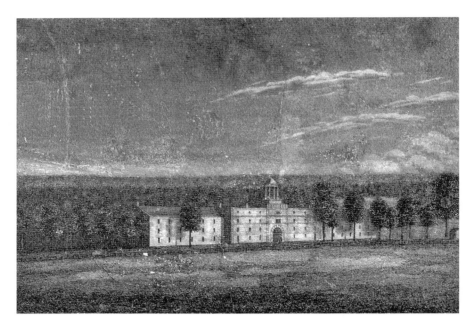

The original Tennessee State Prison on Church Street was in use from 1830 until 1898. *Courtesy of the Hermitage.*

something that made his hair stand up. He swore "on my honor as a man, I saw [Ben Brown] dressed in his long, black coat holding his book in his hand." The apparition approached the bars, muttering quietly, and "glared at me just as he did the night before he was hung." The occupant of the cell next door nodded solemnly. He told the jailer that he, too, had seen Ben since his execution.[87]

With that last hurrah, the ghosts of Ben Brown and Frank Arnold seemed to vanish into the night, taking with them all the answers to the many questions that still hang around this most gruesome crime.

COP KILLER

It was nearing eight o'clock on the chilly evening of Sunday, December 6, 1903, and the congregation of Grace Presbyterian Church settled into the pews, listening to the minister speak on his chosen topic for the evening: "Let me die the death of the righteous." The topic proved most appropriate.[88]

All at once, the preaching was interrupted by string of rapid gunshots outside. The churchgoers began to look around in concern, and then the door flew open and a policeman came stumbling into the foyer, hands stretched out, a smoking .38-caliber revolver dangling from his right hand.

With remarkable calm, the man gasped, "Gentlemen, I've been shot. Take my gun please."[89] Perhaps because of his own composure, the crowd didn't panic. Kind hands disarmed him and led the officer to a pew, where he collapsed. He was soon taken to the Sunday school room and laid on the floor. The women of the church took charge of his care, a bystander noting that they "seemed the calmest of the congregation." Meanwhile, somebody phoned for an ambulance.[90]

The wounded officer was Patrolman Ben Dowell, twenty-seven, a two-year veteran of the force. He had been struck twice during the shooting. One bullet passed through his stomach, while the other took off the tip of his right thumb before going through his liver and lodging in his body. Even after being shot, he'd managed to empty his own revolver at his assailant. When two officers asked who had done it, he named a character they knew very well. It was Tom Cox.

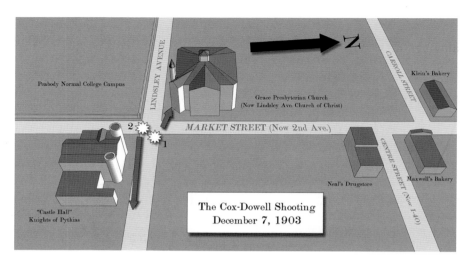

Dowell (1) was ambushed by Cox (2) in front of Castle Hall. The wounded officer staggered into Grace Church, while Cox fled down Lindsley Street. *Author's diagram.*

As the ambulance team galloped toward City Hospital with the gravely wounded officer, a phone call came into the Central Police Station from a most unlikely "good citizen." Saloon keeper Sol Cohn was one of the most notorious gamblers and bootleggers in the city and ran a rough joint on South Cherry Street (now Fourth Avenue), in the heart of the grimiest district in the city, known as "Black Bottom." Cohn's statement raised the eyebrows of the lieutenant who took the call.

He said that Tom Cox was in his place. He was wounded and wanted to surrender and be taken to the hospital.

Two officers quickly took him in and landed him in the city jail instead. A doctor examined his wound and found that one of Dowell's bullets had entered just behind his right wrist and come out through the elbow. It was a very painful wound but not necessarily serious. The gunman was booked for murder and given a cell.

Cox had a long and troubled history in the city. A gambler and bartender in many of the dives of "Black Bottom," he was known as a trigger-happy sort with a quick temper. In the past few years, he had shot three men, killing one, and had been run in for various assaults. It was quite evident that Cox ran with a "connected" crowd. His one conviction—for wounding a policeman in 1896—had gone all the way to the state Supreme Court, which upheld his sentence. Two days later, he was given a full pardon by Governor Robert L. Taylor.[91]

Remarkably, the young man did not deny shooting Officer Dowell, although he said he wasn't hunting him. He merely wanted to talk. Earlier that afternoon, Dowell had arrested his sister, Mrs. Nellie McDonough, whom he suspected of running her husband's saloon in violation of the Sunday law. He claimed Dowell had abused and even slapped his sister, and when he approached the officer and tried to ask him about it in a reasonable manner, Dowell had cursed him and opened fire. Jaws must have dropped open: he was claiming he'd shot Dowell in self-defense.

Not surprisingly, the officers at the station told a different tale. When Nellie was booked that afternoon, Cox had appeared and signed her bond. When he asked what had happened, she told him she'd been roughed up by Dowell. Ominously, her brother replied that she shouldn't worry—he would "go at once and settle the matter."[92] Bystanders said that even Nellie looked worried about what he intended to do.

Incidentally, the owner of the store where the arrest took place contradicted Cox's account, saying the officer acted with remarkable patience and in a "gentlemanly" fashion. He staunchly denied that Dowell had struck the lady, whom he said had been abusive and profane toward the officer.

Lying in his bed at City Hospital, the wounded Dowell was very weak, and his doctors gave him little chance of recovery. His wife, Allie, arrived with some relatives about an hour after he was admitted. She was understandably in deep shock as she sat by her stricken husband's bedside. As his condition worsened, Dowell gave his own deathbed statement, in which he asserted that Cox had approached without warning and fired his .41 Colt from inside his overcoat pocket—"as cowardly a trick as a man ever did." He told another friend that he'd been shot down "like a dog."[93]

Late in the afternoon of December 7, 1903, he slipped into unconsciousness. After twenty-three excruciating hours, he finally passed away at 7:05 p.m.

Benjamin Franklin Dowell was born on July 15, 1876. He had joined the force in 1901 after working for the Nashville Gas Company for a number of years. He was survived by his wife, the former Alice Mae Woodward, and an infant daughter. Their marriage had barely lasted a year.

As an officer, he'd proven a tough customer. On one occasion, he held a mob at bay single-handed while making a difficult arrest. A year earlier, he and a partner had shot it out with two brothers named Webb in "Black Bottom," although nobody was hit. He also proved he could think on his feet. While trying to arrest two young boys he caught "skinny-dipping" in Centennial Park, he found himself in a ludicrous situation, chasing the two

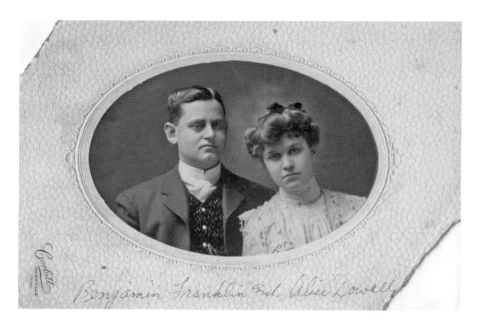

Benjamin F. Dowell (left), photographed in happier times with his wife, Alice. *Courtesy of Valerie McCauely.*

naked kids through the streets. He called a truce, told the boys to come to him and explained why they couldn't go around "streaking" the neighborhood. He then let them dress and go home without charging them.

On December 9, crowds packed Grace Presbyterian Church to pay their final respects to the fallen officer. Just yards from the scene of the shooting, Dowell lay in state in a flag-draped coffin, surrounded by mountains of flowers. An honor guard of seventy policemen surrounded the bier. In attendance was Mayor Albert S. Williams and "nearly every public official in Nashville." The funeral sermon was a call to arms against vice, stating that "the saloon and the gambler killed Ben Dowell."[94] The voice of the reformers was calling for more than blood; they wanted to clean house.

The police were not idle. Almost immediately, Nellie Cox McDonough and her husband, Owen, were arrested as accessories. At her hearing, witnesses testified that during her arrest she had told Dowell point blank, "You're as good as in the graveyard. You're as good as dead. I'll make my brother Tom Cox kill you, you cowardly son of a bitch!"[95] Burke Thompson, a friend of Cox, was also arrested. Witnesses believed he had pointed out Dowell to his killer before the shooting. Interestingly, Thompson's brother Ben was himself a member of the police force.

Dowell was shot just outside of Grace Presbyterian Church. Today, the building houses the Lindsley Avenue Church of Christ. *Author's photo.*

Outrage grew when it came out that the saloon crowd had started a fund to pay for Cox's defense. A counter-fund was raised to help pay Dowell's final expenses, as well as to fund his killer's prosecution.[96] This back-and-forth "crowd funding" would help retain some of the sharpest legal minds in the city and ensure the courtroom battle to come would be lively. It began just over a year later.

The case of the *State v. Tom Cox, Nellie McDonough and Burke Thompson* opened on February 2, 1904, and from the beginning it was apparent that Cox was in a literal fight for his life. The opposing counsel dueled constantly over every aspect of the case. Three jurymen were disqualified almost immediately, and replacements had to be found, causing a ten-day delay. The defense then unsuccessfully objected to Dowell's dying statement being admitted as evidence. The prosecution hammered away, presenting witness after witness who testified that Nellie had threatened the officer, Burke Thompson had pointed him out and Cox had simply walked up to him and opened fire without warning.

The defense put Cox on the stand; he told his original story that he was simply trying to discuss things with Dowell, who opened fire without warning,

After being shot, the wounded patrolman was taken to the City Hospital, where he later died of his wounds. *Courtesy Metro Nashville Archives.*

and that he had fired back only after being shot through the arm. His lawyers attacked the officer's dying statement and also produced several eyewitnesses for their client. Among these was Jim Morris, who stated that the officer clearly had his hand on his gun under his coat before Cox appeared and that he'd fired first. His testimony backfired in a remarkable way.

The night after he took the stand, the prosecution sent investigators to question Jim Morris's mother and sister-in-law, who both swore that he was at home with them the night of the shooting. As court opened the next morning, Morris was brought back to the stand and confronted with this evidence. He sheepishly admitted that he'd been promised a reward to lie under oath and was promptly charged with perjury. It was one of those "courtroom sensations" so beloved by the movies that rarely happen in real life. The defense sputtered that they'd been "imposed upon" by the witness, but it didn't matter: Morris had just torpedoed their case. Morris was later tried and given twelve years in prison. At least four other defense witnesses were also charged with perjury for their testimony in the months to come.

Still, with all the confusion, it took a week of deliberation before the jury returned its verdict: guilty of murder in the first degree, with mitigating circumstances. The circumstances were not mitigating enough: Tom Cox was sentenced to hang. The defense team immediately petitioned for a new trial. It fought for its client tooth and nail, but the perjured testimony was enough to overcome any exceptions. On March 19, the motion was denied and the sentence upheld. The case, as was customary in a death penalty case, went to the Supreme Court, which also upheld the verdict. Cox's execution was scheduled for the spring of 1905.

The condemned man still had plenty of friends with connections, and while he sat on death row awaiting his fate, petitions were given to outgoing governor James B. Frazier and incoming governor John I. Cox (no relation). Tom, to the surprise of many, remained convinced that he would receive executive clemency. It turned out he was sadly deceived. The best he got was a three-week reprieve, after which Governor Cox announced that he would allow the law to take its course.

Tom, on the other hand, had no such intention. He had one last surprise up his sleeve.

By all accounts, the young desperado was devastated by the failure of his final appeal, but he still maintained that he would never hang. He was right. At five o'clock on the morning of May 3, 1905—two days before he was to march to the gallows—the jailer found Cox bathed in sweat, his eyes "blazing,"[97] tossing around in great pain on his straw mattress. Help was summoned, and doctors quickly realized what was happening. He had swallowed a lethal dose of opium and red oxide of mercury.

Exactly where the substance came from was a mystery. Since the governor had rejected his pardon, the sheriff had his prisoner under a "suicide watch," yet he had still managed to get his hands on it. Cox left a note in his cell, claiming he'd had the poison for "a long time" and that a former cellmate had given it to him, but officials at the time thought that sounded unlikely. Where the stuff actually came from is still unknown.[98]

For fifteen hours, the medical men labored to save his life, pumping his stomach and treating his symptoms. He was in such terrible agony that toward the end, he admitted it would have been better if he had just been hanged. He died at 8:00 p.m. in his cell, his grief-stricken mother, Mary, by his cot. He was just thirty years old.

Tom Cox died by his own hand two days before he was supposed to hang. He had killed two men and was divorced from his wife. No priest heard his final confession or gave him his last rites. Despite all that, he was given the

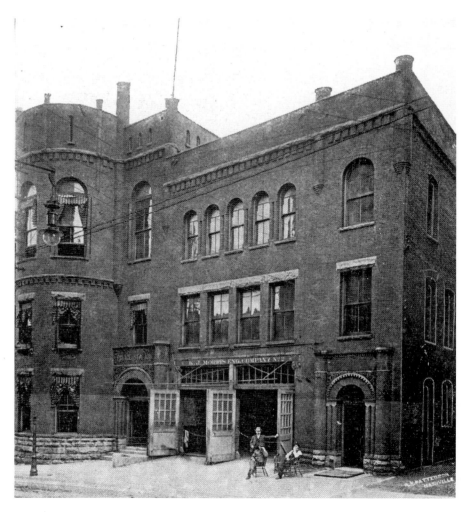

The Nashville Police Station in 1904. *Courtesy Metro Nashville Archives.*

final solace of a faith he seemed to hold in little regard for much of his life. His funeral took place at St. Mary's Catholic Church, followed by burial in Calvary Cemetery.

With Tom Cox's death came the final reckoning in this sad chapter of violence. He left staunch friends and supporters to mourn him, while Dowell left a devastated family and a young widow to raise their only child alone. In the end, there were no winners, and even justice came up short in this forgotten tragedy of the long battle between whiskey and reformers for Nashville's soul.

SEVENTH AVENUE SHOWDOWN

A bronze figure dressed in a frock coat stands today in front of the state capitol, perched as if it's about to do a swan dive onto Charlotte Avenue. Ask the average passerby who it is and you're likely to get a blank stare. Others might hazard a guess: Mark Twain and restaurant pioneer Colonel Sanders have been mentioned as possibilities. Few know that it stands as a reminder of a crime long forgotten that took place only a few blocks away, one that had long-lasting implications for the entire state of Tennessee.

By the turn of the twentieth century, a heated debate was underway at all levels of society about the effects of a substance that had long been identified with the state: alcohol. From the time Tennessee was founded, John Barleycorn had found a home there. Two of the most beloved brands of whiskey were founded in the years after the Civil War, and many honorable men (and women, it was whispered) enjoyed an occasional sip of "the creature."

However, it was also apparent that drinking was causing a lot of problems. Alcoholism destroyed homes and careers and led to all sorts of vice and crime, leading to a reform movement that increasingly fought against what it perceived as the greatest social evil known to man. The debate had raged for thirty years, and by the second decade of the 1900s, it was coming to a head.

Among the leaders of the anti-liquor forces was a fiery, sharp-tongued editor named Edward Ward Carmack, who had long been a lightning rod of controversy. Born in Sumner County on November 5, 1858, he had first hung out his shingle as an attorney in Columbia during the 1870s. It wasn't

A newspaper war between Senator Carmack and Duncan B. Cooper resulted in a showdown that shocked all of Tennessee. *Library of Congress.*

long before he got into politics and parleyed local support into a successful bid for a seat in the state House of Representatives. He went on to serve a term in the U.S. Senate. Carmack was an eloquent and passionate speaker with great charisma. But as with many other public crusaders, his boundless confidence could often make him appear self-righteous and obnoxious. He quickly became a leading voice against alcohol and gambling interests.

Early in his career, he made the acquaintance of a prominent newspaperman who opened his eyes to the power of the press. Duncan Brown Cooper was often referred to as "Colonel" after serving as a Confederate guerrilla leader during the Civil War. Thirteen years Carmack's senior, he was the owner of the *Nashville American* in 1888, when he offered the young firebrand a position as an editor. Over the years, Carmack would skillfully use his editorial platform to further his causes and attack his rivals, and his acid tongue and way with words were both admired and feared. He later went on to positions with the *Memphis Commercial Appeal* and the *Nashville Tennessean*. Colonel Cooper was more conservative than his protégé, but despite their differences, the two remained close friends.

Given his abrasive and unbending nature, it seemed inevitable that Carmack was destined for serious trouble, and things began to go south

after the turn of the century. In 1907, he ran for another term in the U.S. Senate against former governor Bob Taylor, a "yaller dog" Democrat and a longtime friend of liquor. As expected, there was a good amount of name-calling during the heated contest. In the end, the voters of Tennessee decided against Carmack. Undaunted, he regrouped and the following year ran for governor of Tennessee.

The primary was especially bitter and led to vicious infighting within the Democratic Party. In the end, Carmack's support among the churches and temperance unions wasn't enough to overcome the clout of the distillers and saloon men. The nomination went to Malcolm R. Patterson, a dyed-in-the-wool "wet."

Much of the mudslinging was launched from the editorial pages. Carmack, as always, used the *Tennessean* to denounce Patterson's allies, while the opposition press fired back from the *Nashville Banner*, denouncing Carmack as an opportunist and a hypocrite. Old friends were caught in the crossfire.

Carmack's defeats seem to have embittered him, and his sarcasm was as indiscriminate as a shotgun. On several occasions, he threw jabs at his old mentor Cooper, implying that he was a corrupt political puppet. As might be imagined with his "Old South" upbringing, the old man's honor was burned, and he seethed with outrage. Several times he asked Carmack to desist, pointing out that he was not a public figure, nor was he himself running for office. Such personal attacks could serve no great purpose and appeared petty, he said. Carmack ignored him.

Everything came to a point on November 8, 1908. The morning edition of the *Tennessean* contained a piece titled "Across the Muddy Chasm," in which Carmack lit into his former friend with rare eloquence. An associate ran into Cooper that morning in the Tulane Hotel and noted that the old man was shaking with rage. He stated point-blank that if his name again appeared in the paper, "he or Senator Carmack must die."[99]

Friends attempted to intervene, but neither man would back down. After veiled threats were exchanged, Carmack was sufficiently concerned that he obtained a revolver, which he began carrying in his coat pocket—just in case. And then, true to form, he scribbled another scathing editorial for publication in the next morning's paper.

The next morning, Cooper stormed into the office of his son, attorney Robin Jones Cooper. In a towering rage, he roared that he intended to find Carmack and settle the matter. Robin, only twenty-six, was in an unenviable position as he tried to both protect his father and steer him away from trouble. Over the course of the next few hours, various parties tried to arrange a

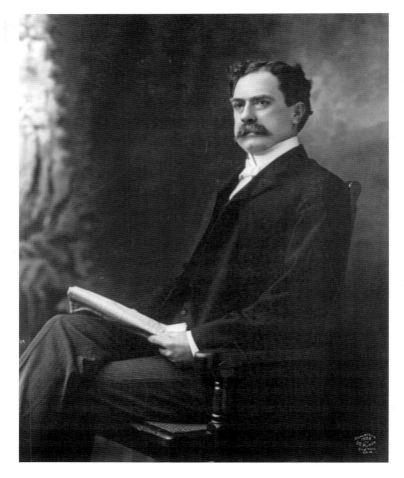

Edward Ward Carmack was Tennessee's longtime crusader against the evils of alcohol and gambling. His politics gained him many enemies. *Library of Congress.*

compromise to head off the trouble that was brewing. The proceedings were loaded with political dynamite: phone calls went all the way up to Governor Patterson himself to advise of the situation. At one point, Patterson advised Robin, "If I were in your place, I would stay with my father as much as I could to-day."[100]

Colonel Cooper was packing a pistol as was his habit. Still, Robin reasoned that at sixty-five years old, and with a rheumatic right hand, his father stood little chance in a street fight. So Robin approached an uncle from whom he borrowed a small automatic pistol—just in case.

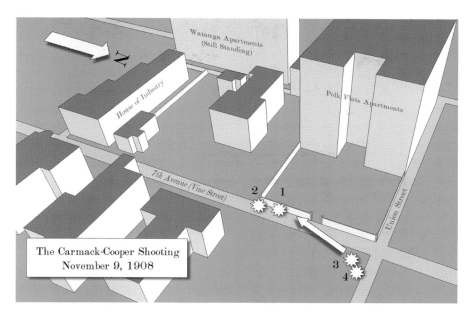

Carmack (1) was talking to Mrs. Eastman (2) when Duncan (3) and Robin Cooper (4) approached from across Seventh Avenue. *Author's diagram.*

To their credit, the two Coopers seem to have made some effort to avoid the object of their loathing. Late in the afternoon, they set out to meet Patterson at the executive mansion, walking through the Arcade (Nashville's first mall) and up Union to Seventh, taking a roundabout route to avoid Carmack's usual routine. But as they got to the corner of Union, Robin spied Carmack's familiar figure heading for his lodging at the Polk Flats apartment building. Nervously, he made an attempt to distract his father, but it was too late. As soon as he spotted his quarry, Colonel Cooper headed over to confront him while Robin followed, desperately begging him to stop.

Near the apartment's gate, Carmack had just greeted his neighbor Mrs. Eastman when Cooper shouted to him from behind. The senator turned, and when he recognized his enemy, he began fumbling in his pocket for his pistol. Bystanders screamed and scrambled out of the way as the street exploded with a volley of gunfire.

It was all over in seconds. Carmack collapsed on the sidewalk next to two telephone poles with bullets in his left arm, his chest and the base of his skull. Robin Cooper stood swaying with an empty pistol in his hand. One of Carmack's bullets had hit him in the shoulder beneath the collarbone, inflicting a painful but not serious wound. Ironically, he had done all the

shooting in his father's fight. Colonel Cooper was unharmed, his unfired pistol still in his hand.[101]

To say that the daylight shootout was a sensation would be a gross understatement, and the episode was quickly cast by both factions as a conspiracy. To the "drys," it was an obvious case of a crusader for temperance being gunned down by assassins backed by the saloon interests. To the "wets," it was a case of a do-gooder trying to provoke a fight and getting what he was asking for. The truth lay somewhere in the middle, as always, but with passions running high it remained to be seen if justice could be served.

The trial was a three-ring media circus. The actions of both Cooper and Carmack were put under the microscope, and the testimony of every witness was flayed with surgical precision. When all the hype is taken away, the most balanced thing that can be said about the actions of both men is what the poet John Saxe once wrote: "Each was partly in the right, and all were in the wrong." In the end, the jury decided that both Coopers were guilty of murder. As could be expected in such a high-profile case, the appeals made it all the way to the Supreme Court.

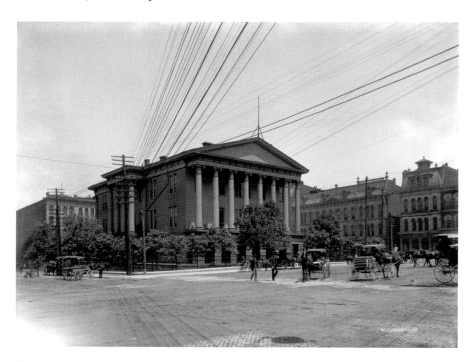

Nashville's third courthouse, completed in 1857, was the scene of the sensational trial of Duncan and Robin Cooper. It was torn down in 1935. *Library of Congress.*

In 1910, the court made its ruling. Robin Cooper's conviction was reversed, the court citing improper procedure.[102] On the other hand, the court upheld Duncan Cooper's conviction, even though he hadn't fired a shot. As the instigating party, they maintained, he was guilty of bringing about Carmack's death. However, if the "dry" forces were hoping to see Cooper languish in prison for martyring their man, they would be rudely disappointed.

On the very same day that the high court made its ruling, Governor Malcolm Patterson used his executive powers to issue a full pardon to his old buddy, Duncan Brown Cooper.[103] The old man was free to retire to Riverview, his home near Nashville. He lived there in relative peace for the remainder of his life, dying on November 4, 1923.

Though he managed to save his friend from prison, the blatant political maneuver backfired on Patterson. Of the many acts that outraged the reformers during his administration, the Cooper pardon was one of the most blatant. Patterson managed to squeak into a second term, but his name was mud. In 1909, the legislature passed a statewide prohibition law, ignoring the governor's veto. So bad did things become that his own party split in two, and in 1911, voters did something that was considered impossible in Tennessee: for the first time in nearly forty years, they elected a Republican governor.

In the end, Carmack's death helped hamstring the liquor supporters in a way his rhetoric was never able to. Ironically, it also helped usher in a far more violent and vice-ridden era that he probably couldn't have imagined.

In 1925, admirers finally managed to raise the statue on Seventh Avenue to honor their hero, who died that others might not drink. Legend has it that it was so poised that legislators were forced to walk beneath Carmack's withering gaze as they entered the statehouse to conduct business. Legend also says that thirty years later, the pedestrian tunnel under the statue was installed so that lawmakers would no longer have to look at it. The Motlow Tunnel, as it is known, certainly was named in honor of the family who owned the famous Jack Daniels distillery. Or so goes the story.

There is one final unresolved mystery in the case. On August 30, 1919, the mud-spattered body of Robin J. Cooper was found facedown in Richland Creek, a few hundred yards from his automobile, which was parked in fashionable Belle Meade Park. The back of his skull had been knocked in with a bloodstained rock that was found nearby. Despite a massive police inquiry, nobody was ever brought to justice for the murder. Some said it was revenge for his killing Carmack eleven years before. A more plausible theory involved bootleggers and a liquor deal gone bad,

Erected by supporters in 1925, this imposing statue of the slain
Carmack still stands on Seventh Avenue, a reminder of his untimely
end. *Author's photo.*

making him possibly one of the earliest and most prominent victims of
Prohibition-era violence in the city.[104]

If the theory about liquor is true, it is one last bit of irony that the man
who killed the champion of Prohibition should meet his end at the hands of
folks who—however inadvertently—owed their prosperity to his actions. But
then again, who knows? It seems nothing is ever that simple when Tennessee
politics are involved.

GUNFIRE ON THE WESTERN FRONT

In the tide of outrage following the death of Senator Carmack (see chapter 9), the legislature outlawed the sale of liquor in the state. From 1909 until 1939, Tennessee was committed to the "noble experiment," hoping to make drunkenness and its attendant vice and crime a thing of the past.

What actually happened might have served as a template for the nationwide law to come. Almost as soon as the ink was dry on the law, an army of smugglers was at work selling bootleg hooch to thirsty clients. The reformers reacted by tightening the laws; in 1914, the "bone dry" law made it illegal to buy booze in the surrounding states for resale in Tennessee. The new law gave a shot in the arm to local moonshiners, while "blockade runners" continued bringing in "the good stuff" at night along the dirt back roads around Nashville, Knoxville and Memphis.

By the time Prohibition became national law in 1919, Nashville's rumrunners had ten years of hard experience in setting up their networks. Taxicab drivers acted as smugglers and soda jerks as sales clerks, and all of it run by "savvy businessmen" with connections to suppliers outside the state.

Naturally, the business was fraught with danger, and bootleggers couldn't go to the cops if there was trouble. The bigger operators had to have a mean streak to stay in business, and many were handy with a gun. Unlike Chicago or St. Louis, Nashville never had roving gangs of Tommy gun-wielding thugs shooting it out with one another, but the city saw its share of violence nevertheless. Over the course of the era, there would be instances of gunplay, double-dealing and betrayal worthy of an Edward G. Robinson

By 1915, a night owl in Nashville would have no problem finding a drink downtown, despite the fact that the state had been dry for six years. *Courtesy Tennessee State Library and Archives.*

gangster film. The action got so intense that the heart of the liquor trade on Sixth Avenue would become known as the "Western Front." And for some, it would be just as lethal as its namesake in France.

By 1918, shootouts had become commonplace. Characters with colorful nicknames like "Scudder" Hosse and "Kid" Wolfe went down under the guns of rivals or the police, but these were mostly small-time cowboys fighting over turf.[105] By the mid-1920s, a more organized breed was running things, and their greed grew along with their profits. What followed was an underworld "War of the Roses," as rivals maneuvered against one another and alliances shifted overnight in a winner-take-all contest for control of the city.

The first of these so-called kings of the underworld to make the papers was Frank B. Christman, a former policeman who had gotten into the rackets after quitting the force. He was a tough customer and quick with a gun, something his business partner Ernest "Abbie" Arnett probably should have taken into account. Arnett was a razor-sharp accountant who apparently figured that he was the brains behind Christman's operation and decided to branch out on his own. Sadly, he hadn't calculated that brawn was just as important as brains in this sort of business, and he had badly underestimated Christman's wrath.

On the freezing morning of February 6, 1924, Christman walked into Mooney's fruit store at the corner of Fourth and Cedar (now Charlotte), where he saw Arnett talking on the pay phone with his back to the door.

A roomful of contraband liquor seized during a raid in 1908. Scenes like this were common for thirty years in Nashville. *Courtesy Tennessee State Library and Archives.*

Without a word, he pulled his .38 and fired one shot into the back of Arnett's head, killing him instantly. The shooting took place in full view of several witnesses, including a city policeman, who was too shocked to stop it.[106]

Even more brazen was Christman's plea: self-defense. His logic ran that since Arnett had allegedly threatened his life, and since his victim was packing a .45 at the time he died, he had simply gotten there first. Looking back, one can infer the kind of "pull" a big-time bootlegger had in those days. It took two tries for the grand jury to even indict him, and his first trial ended in a hung jury. After three years of legal acrobatics, he was finally found guilty of murder.

On July 15, 1927, Frank Christman entered the state penitentiary to begin a twenty-one-year sentence. He barely did three. Released in 1930, he apparently kept his nose clean afterward and stayed out of the headlines until his death from natural causes in 1938 at the age of fifty-six.[107]

With Christman's early retirement, the newspapers began wondering who would become the new "king of the bootleggers." Soon, it appeared that an old veteran had claimed the title.

Harry Lehman was forty-five and had lived in Nashville since the turn of the century. He had first come to prominence when he shot Burke Thompson after a barroom argument in 1902. He beat the rap in that case, and Thompson recovered, only to be implicated in the murder of Officer Ben Dowell the following year (see chapter 8).

Lehman had a long record of arrests for violation of the prohibition law and had last done time in 1913, when he spent three months "on the rock pile" in the workhouse after being caught red-handed.[108] Time had apparently not mellowed him, and by the mid-'20s he was considered a major player in the liquor scene. He kept peace with rivals like Christman and worked around them rather than against them.

Modern police methods: a suspect is booked at the police station in 1926. *Courtesy Metro Nashville Archives.*

But in 1926, he ran into serious trouble. The government finally made a case against him and successfully "flipped" his supposed right-hand man, Will A. Latta. Several other close friends also turned on him, giving damning testimony at his trial. Lehman defended himself in a rather surprising way.

On October 21, he took the stand himself as a witness, and to the amazement of spectators, he testified that Latta had been actively using his status as a paid informant for the government to put rivals out of business. Meanwhile, he continued to run his own liquor unchecked. The court was treated to the sight of the notorious bootleg "king" reading from his own account book on the stand, cherry-picking the most damning entries in order to undercut Latta's testimony.[109] It wasn't enough. He was found guilty of violation of the liquor laws, but during the appeal process, he remained free.

Latta didn't last too much longer. On March 31, 1927, he was parked in his car at a filling station at the corner of Elm Hill Pike and Murfreesboro Road, talking to a suspected bootlegger named Kyle Davenport. Exactly what happened is unclear, but suddenly the inside of the car was lit up by gunfire. Davenport tumbled out unharmed. Latta slumped behind the wheel, a bullet in his chest. Davenport claimed that Latta had tried to shake him down and then went for a gun, and he'd fired in self-defense. At his trial four months later, he was acquitted.[110]

On August 16, a troubled Lehman, his appeal still pending, threw a party at a house in the tiny hamlet of Kingston Springs, about twenty-five miles west of Nashville. The group included some of his closest associates, who drank and danced to the sounds laid down by a hired band. All seemed smooth until midnight, when suddenly the party ended in a hail of gunfire. By the time the sheriff arrived, Lehman lay dead on a bedroom floor, shot five times in the head and neck. Lehman's friend, gambler Joe S. Whitmore, soon turned himself in.

As expected, Whitmore claimed self-defense. He said that Lehman was drunk and in an ugly mood and that he had been slapping around a woman at the party whom Whitmore was sweet on. When the gambler protested, Lehman went for a gun.[111]

Investigators cast some doubt on the claim when they found a bullet hole behind Lehman's right ear with powder burns around it, indicating a very close-range shot, and signs that he'd been beaten severely. There were also indications that two gunmen had fired, cutting the bootleg king down in a crossfire.[112] Nevertheless, Whitmore's plea was accepted, and he came free at trial in October. Lehman was quietly laid to rest at Mount Olivet Cemetery.

In his wake, a new "king" arose from the ashes. Donley T. Davenport was the brother of Kyle, who had earlier killed Will Latta. The Davenports were colorful characters who were said to run liquor in a special truck outfitted with a razor-sharp ram to cut through roadblocks. They were far more sinister and quiet figures than the flashy Christman and Lehman. At the time he came to prominence, Donley had a record going back to 1924 with no convictions, but in the years to come, he would be twice convicted and sent to the federal prison in Atlanta. There he made a habit of breaking out. He was also suspected of involvement in several murders over the course of a decade.[113]

In addition to liquor, the Davenports allegedly became involved in a newer scourge plaguing the city. The Feds believed they ran a narcotics ring, running cocaine, morphine and heroin from New York to Nashville. This unsavory business led to huge profits, but it also brought new stresses and rivalries within the organization that would prove to be their undoing. The breaking point came on July 3, 1933.

Just before dawn, a passerby stumbled on a gruesome scene about a mile outside the rural town of Una, west of the city. A two-door coupe sat parked in the weeds beside Anderson's Lane with its doors open and two bodies sprawled across the front seat. William A. "Red" Craig, age thirty-eight, lay in the road with his feet on the running board, his head half blown off by a shotgun. The body of twenty-eight-year-old Ruth Davenport, the wife of Donley's son Charles, lay with her head under the steering wheel. She had been killed by two blasts of number seven shot in the chest. Her death was especially ruthless—Ruth suffered from "chalk bones" (osteoporosis) and could barely move. Her crutches still lay tucked behind the seat.[114]

Craig's death was no surprise to anyone. A suspected drug runner from Memphis, he'd recently been released from prison after serving time for murder. Inside, he'd run a drug ring and frequently stiffed his customers. On his death certificate, the coroner flatly listed his occupation as "Gangster."[115]

Ruth Davenport was another matter. Her husband was currently doing time on a liquor charge in North Carolina, but it was hard to picture the young woman with leg braces as a threat to anyone. Police were stumped—was it an illicit affair? Maybe a drug deal gone bad? Rival bootleggers? As the shocking news spread across Nashville, District Attorney Richard M. Atkinson launched a thorough investigation. Atkinson, a tough U.S. Marine Corps veteran of the world war, would prove a formidable foe.

As drug dealers and couriers were rounded up and put to the "third degree," the underworld hit back. At least two threatening notes were sent

Patrol guard "Uncle Jack" Connors with a prisoner inside the cellblock at the city jail, 1926. *Courtesy Metro Nashville Archives.*

to authorities, warning them to lay off. Several times, Atkinson was phoned by mysterious "informants," trying to lure him out to isolated places with the promise of important information. He didn't take the bait. As the threats came in, the sheriff reportedly told his men to carry two guns each and "shoot to kill" without warning.[116] Then the ante was raised when another body turned up.

On July 12, the remains of Raymond J. Scott were found, severely beaten and stabbed, by the Tennessee Central railroad tracks five miles south of town. It turned out that Scott had been an addict and a "snitch" from Knoxville who had put away several narcotics dealers. He had made a sudden and unexpected trip to Nashville, apparently to tell the authorities what he knew. Someone had silenced him the same day he arrived, so quickly that his sister later said she didn't even know he was in town.[117]

A bustling crowd on Union Street around 1920. *Courtesy Metro Nashville Archives.*

Despite the intimidation and silencing of witnesses, the DA kept hammering. After a two-week inquiry, the investigation wrapped up with a dramatic scene straight out of a pulp novel. On July 29, 1933, Atkinson invited Donley Davenport to his office to discuss his findings.

As it was later told, the DA laid out the case as he sat in his stuffy office that evening, explaining that they finally knew who had done it. Davenport asked, "Who is the son of a bitch?"

The DA smiled thinly before dropping the bomb. "That's you, Donley," he replied. "You did it. And you're under arrest." It's a great story. And maybe it really did happen that way.[118]

According to authorities, Craig had stiffed his bosses on a deal for two pounds of cocaine, and Davenport had okayed a hit on him. Ruth was at that time trying to raise money for her husband's legal battle for a new trial and had met with Craig to broker a drug deal. She'd already had several violent arguments with Davenport in the past, and the two loathed each other. Informants said that Donley decided to make it a two-for-one and personally wielded the shotgun that cut down Craig and his daughter-in-law.

For his part, Davenport staunchly maintained his innocence, but the jury didn't believe him. He was sentenced to ninety-nine years, and when the appeals ran out, the fifty-year-old entered the state prison to start his term. At his age, he probably knew he would never get out, and so it went. He died in prison on January 18, 1943, of heart disease and was buried in Mount Olivet Cemetery.[119]

That left only the oldest dog still standing. And sadly, he almost got away with it.

Solomon Cohn was born in 1868, the scion of one of the most prominent Jewish families in Nashville. As a youth, he was pious and upstanding, regularly singing during events at the Vine Street Temple. But sometime after that, young Sol went off the track.

He began running what were known as "black and tans," saloons that catered to anybody with cash, regardless of whether they were black or white. In segregated Victorian Nashville, it was enough to mark his establishments as the lowest of the low. Sol didn't care—his equal opportunity outlook ended up making him a fortune from liquor and illegal gambling. By the turn of the century, he was considered the "King of Black Bottom," the roughest district of dives in the city.

Sol could be as hard as the rest of them. In his youth, he carried a knife and beat a couple of murder raps. However, he also had a cheekiness that was downright charming. Once, during a courtroom showdown, an attorney asked him why he was carrying his walking stick on the stand. Sol smiled and replied, "I brought it along to paddle you with." The attorney laughed along with the rest.[120] It's also typical of the man that at the height of Prohibition in 1913, Cohn filed a patent for his own liquor label: a brand he called "Cream of the Crop."[121]

Many said Cohn was the real "King of the Bootleggers" all along, but by the early 1920s he was looking to get out of the rackets—at least publicly. He invested his ill-gotten means in legitimate businesses and lived well and respectably, looking for all the world like a kindly white-haired grandpa to those who didn't know his reputation. Then came Black Tuesday in 1929, and in the years after the stock market crash, his legitimate investments dried up, leaving him desperate for income. He resorted to his roots.

It's a bit pathetic that a sixty-seven-year-old Sol Cohn was nabbed while personally driving a truck full of illegal hooch on Dickerson Road by a motorcycle cop on February 13, 1935. He maintained that he was only transporting it through Tennessee for resale elsewhere—which was technically legal, as the Volstead Act had been repealed two years before.

During the "gangster era," Al Capone, Harry Pierpont, "Baby Face" Nelson and Buck Barrow all passed through Nashville's Union Station. *Library of Congress.*

However, the jury didn't believe him, and he was sentenced to one to five years in state prison.[122]

Perhaps in the end the authorities felt sorry for him, as the old bootlegger was paroled just nine months later, in October 1937. In poor health, he retired to his home on Woodmont Boulevard, where he died on April 30, 1939. His troubles over, he rests today like so many others in Mount Olivet. His passing—literally—marked the end of an era.[123]

For six years after the nation had rejected Prohibition, Tennessee stubbornly held to the narrow path. But finally, on May 11, 1939, Nashville voters went to the polls to decide whether their city would stay dry or go wet. Two weeks after Cohn was laid to rest, the community voted for repeal, and the first legal alcohol in a generation began crossing bars and store counters across town. Reportedly, quite a lot of folks that night got happily—and legally—drunk.

It had been a three-decade struggle, with more shootouts and dead bodies than a quiet southern town should have seen. In the end, though, Nashville's "bootleg wars" had ended not with a shootout but with a blowout.

OVER THE WALL

The Tennessee State Prison was completed in 1898, and for nearly a century, it stood like a fortress west of the city, housing those whom society would rather forget. The inmates referred to it as "Old Red Top" from its red-tiled roof, and over the years it earned a reputation as a very tough place to do time.

Whenever desperate people are locked away against their will, they inevitably attempt to break free. Tennessee's prison was no different from any other, and over the years it saw its share of escape attempts. Some were dramatic, most were mundane but a handful stood out from the rest. And for audacity, desperation and sheer violence, few incidents in its history matched the desperate bid for freedom made by five hardened cons on November 10, 1938.

One of them was Horace Woodruff, who remembered that the early 1930s were an especially low period in the prison's history. "Life was cheap and uncertain," he wrote. "Fist fights and knife fights were common . . . though there were beatings and floggings every day, discipline was a lost word."[124] There were nearly 2,400 men living in a place designed for 1,500. Gangs preyed on the weaker inmates, and by his count, there were fifty-seven murders in one eighteen-month period. Food was rotten, punishment arbitrary and harsh and sanitation a joke. New arrivals actually walked underneath a large sign over the gate that proclaimed, "Abandon All Hope, Ye Who Enter Here."[125]

Naturally, tensions were high among the staff with that many dangerous people in proximity. An electric wiring system was in place, designed to "fry"

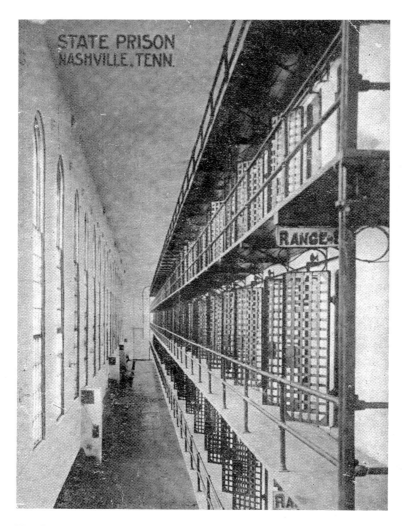

The East Wing cellblock of the state prison around 1910. Prisoners in the squalid, overcrowded cells baked in summer and froze in winter. *Author's collection.*

anyone who came in contact with it. The officers themselves were tough customers, and training was rudimentary at the time. Many were apt to reach for a nightstick or a revolver with little hesitation. Floggings were freely given for infractions, as was time in solitary confinement. Minor offenders were confined in the "Red Line" cells, while the true incorrigibles were put on the "White Line." Woodruff spent more time on the White Line than in general population and professed that he was rarely, if ever, told what he was

being punished for. The abuse tended to take men who were already violent and unstable and make them worse.

Woodruff, for example, was considered one of the worst men inside at the time. He was thirty-two years old, a former marine turned hardened cop killer who had barely escaped the electric chair after gunning down Nashville policeman Mike Mulvihill during a robbery in 1931. Six years of hard time—including one three-year stretch in solitary—had made him a sullen and hate-filled time bomb waiting to go off.

The men he associated with were a lot like him. Lonny Taylor, age thirty-three, was a notorious Knoxville bad man doing a stretch for robbery. Originally sentenced to twenty years, he had recently taken part in an escape attempt in which a trustee had been killed. For this, he had ninety-nine years tacked onto his original sentence. It was supposed to keep him inside for good; instead, it made him "stir crazy" and desperate to get out.[126]

Rufus Guy, age twenty-nine, was another dangerous customer. A veteran of Nashville's notorious Blue Sedan Gang, he was doing ninety-nine years for killing Officer Charles Sanders during a shootout in 1934. Tough, ruthless and intelligent, he was considered one of the most incorrigible prisoners in the institution and had escaped himself several times.[127] When these three got their heads together, trouble couldn't be far behind.

The year 1937 saw some improvement when Governor Gordon Browning took office and launched a prison reform program. Some of the worst excesses were curbed, and the men allowed some privileges. For example, the inmates were allowed to form a musical group and practice in a band room that was set up on the second floor of one of the industrial buildings in the yard. It was hoped that the reforms would take some of the building pressure off the prison, but it would eventually prove to have the opposite effect.

Joe Pope was appointed as the new warden, but the day-to-day running of the prison fell to his deputy warden, Dr. Cullen C. Woods, a man with a rather colorful past. He was a veteran of the Spanish-American War, after which he had served as a lawman in Texas during the waning days of the Wild West. His health was poor, but he was still tough as rawhide, and the prisoners soon nicknamed him "Horse Collar."[128] Woods often chewed the fat in his office with inmates, regaling them with stories of his younger days and demonstrating his quick draw. The papers said he was too trusting of the inmates, and perhaps they were right. Woodruff thought he played favorites and led to friction among the other prisoners.

The escape plot was born during an especially rough stretch on the White Line. Woodruff later called it a "damn good plan," and up to a point it

was. It wasn't overly complicated and took advantage of one of the few privileges the men were allowed. He, Taylor and Guy were all members of the prison band, and they soon noticed that they were not closely watched when they gathered for practice. They also noticed that some guards were carrying pistols when inside the yard, in violation of a cardinal security rule. It wouldn't take much to get hold of some of those guns.

The plan was to use improvised weapons to overpower the guards, disarm them and then force them to open the gate. For added muscle, the three leaders cut in three other inmates on the plan. Millard Lee Edmonds, Milton Harley and Dewey Pinkey were all doing lesser sentences. Edmonds, a former cab driver from Chattanooga doing time for robbery, had once told Woodruff, "I'd rather be dead than live in this damned hellhole."[129] He was welcomed aboard by the others.

Secrets are hard to keep in any prison, and officials later claimed that they'd heard rumors of the plot. If true, they failed to react in time, and on the morning of November 10, the six conspirators quietly gathered in the band room. As other prisoners played an off-key rendition of "Stars and Stripes Forever" to cover the noise, the escapees began luring the guards into

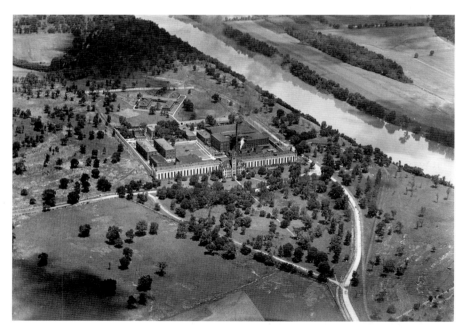

An aerial view of the prison, circa 1930. The truck carrying the escapees fled down the road to the right of the picture, followed closely by police. *Courtesy Metro Nashville Archives.*

the room on one pretext or another. Four guards were eventually rounded up after some struggle, with one man being stabbed by Woodruff and another pistol-whipped by Taylor. Luckily, neither man was fatally hurt.

Then they went to the deputy warden's office, where they caught Dr. Woods and Hub Sampson, the feared captain of the guards, whom the prisoners called "Big Man." The two officers remained cool and calmly informed their gun-toting captors that they were making a serious mistake. Woodruff put his bloody knife to Sampson's throat and told him not to make a worse one.[130]

The escapees originally intended to use a makeshift ladder to get over the wall, but an unexpected opportunity suddenly presented itself. In the yard was a small truck used to haul rocks in from the nearby quarry for construction projects. The engine was running, and a trustee driver sat behind the wheel. The group improvised, commandeering the vehicle and holding the trustee driver at gunpoint as they ordered him to drive out of the yard.

By now, the officials were wise that something was happening, and calls were even being placed to the city police. Warden Pope and others armed themselves and gathered outside as the guard at the "trap gate" stalled for time. The men threatened to kill their hostages if the gate wasn't opened. Eventually, even Woods and Sampson joined the chorus pleading for him to open up, and reluctantly the guard complied.

As the truck drove through the trap gate, it emerged into a hail of gunfire from the guards. At the outer gate, the escapees splintered the guard's wooden booth with gunfire and rammed their way out through the flimsy barricade. One of the hostages jumped clear, and an inmate unconnected with the breakout was seriously wounded in the crossfire before the truck turned onto Centennial Boulevard toward Nashville. They were out.

It was at this point that the plan began to fall apart. For one thing, nobody had thought of what to do once they were out. Even worse for them, the Nashville authorities reacted swiftly and decisively. As the truck crept along seeking a way out of town, it was quickly intercepted by a new piece of law enforcement technology.

The city police force had recently been equipped with "radio cars." These were powerful V-8 Fords equipped with receivers that allowed dispatchers to quickly send them where they were needed—brand-new technology in 1938. Almost immediately, Car 4 fell in behind the truck. While Officer Bill Kennon fired a riot gun out the window, his partner Carney Patterson began a rapid-fire radio report informing dispatch of the escapees' route. Other cars began to block the roads out of town.[131]

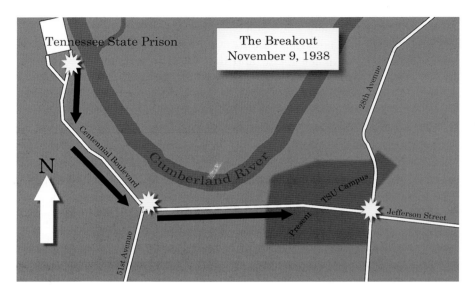

The truck careened along Centennial Boulevard, trading fire with the police until it finally stopped at Twenty-eighth Avenue and Jefferson Street. *Author's diagram.*

The chase continued for over a mile at speeds rarely reaching twenty miles per hour. Bullets and buckshot continually punched holes in the truck's skin, and the convicts fired back as best they could with their commandeered pistols.

Another radio car fell in at Fortieth and Centennial, siren blaring, until a shot from the truck shattered its windshield. The officers inside were scared but unhurt.

Meanwhile, a few blocks ahead, Officers W.A. McDaniel and Jim Turney were directed onto Twenty-eighth Avenue in Cruiser 89 and used the car to block the road at the intersection with Jefferson Street. The officers took cover in a vacant lot and waited until the caravan approached. When the truck spied the roadblock, it slowed down. As it did, the officers jumped up, and McDaniel shot Millard Edmonds square in the head with a load of buckshot. Then all hell broke loose.[132]

Police were converging on the scene armed with Thompson submachine guns, shotguns and rifles, and they literally riddled the truck and its occupants in a nightmarish few seconds of fire. Bill Mayo, the trustee driver, jumped out when the shooting started. His only injury was a cut from a stray shot on the back of his head. Horace Woodruff went down, plastered by buckshot in the arm, leg and hip. Dewey Pinkey and Rufus Guy were both hit in the head and chest, the former seriously. Lonnie Taylor was hit a number of

times, his right arm shattered by machine gun fire. As he collapsed outside the truck, he weakly yelled, "Don't shoot us!"[133]

Gradually, the guns fell silent, and the officers approached the riddled truck. An eyewitness later said that the escapees and their hostages "looked like a bunch of stuck hogs wallowing around in a lot of blood."[134] As they began pulling bodies out, officers found that all the hostages had also been hit. Guard Elmo Green and Hub Sampson had both been shot but not seriously wounded—both went back to work the same day. Deputy Warden Woods, on the other hand, was not so lucky. Several slugs had struck him, one of which passed through his spinal cord and left him paralyzed below the waist. Whether he was shot by the convicts or the officers was unknown.

The wounded prison officials were evacuated by ambulance to St. Thomas Hospital. By contrast, the escapees were roughly thrown into the same blood-spattered truck they had escaped in and driven back to the prison hospital. Rufus Guy's legs dangled off the tailgate all the way back to prison. Woodruff later said that Guy and Lonnie Taylor were both beaten with gun butts on the way back in by angry guards, until a tough Nashville police sergeant aimed a Tommy gun at them and ordered, "Line up over there, you sons of bitches, and let them alone or I'll kill every one of you!"[135] The foolhardy bid for liberty was over a little more than half an hour after it started.

Millard Edmonds, the hard-luck ex-cabbie, never regained consciousness. He died on the operating table a little before 1:00 p.m. Doctors likewise

The escape ended here in a bloody shootout with law enforcement. Today, the scene is close to the entrance to the Tennessee State University campus. *Author's photo.*

didn't hold out much hope for Lonnie Taylor or Dewey Pinkey, but both finally pulled through. However, in the weeks to come, complications set in, making it necessary to amputate Taylor's arm.

All the ringleaders were placed on the White Line to await their fate. The law stated that if any of their hostages died within a year, all three would receive the death sentence, so all eyes were on Deputy Warden Woods, who lay near death at St. Thomas. Woodruff later recalled that the guards took sadistic delight in informing him from time to time that Woods had just died and that the chair was waiting for him. Despite the odds, the tough old lawman clung to life. His family took him home to Waynesboro to care for him. Unfortunately, he never improved.

On February 10, 1940, Cullen C. Woods died of complications from his wound and was buried at Evergreen Cemetery in Murfreesboro.[136] He was sixty-two years old and had lived exactly three months past the deadline hanging over the escapees. Though they would pay heavily in solitary time and petty punishments over the coming years, they all dodged the chair.

The escape marked a turning point for both prison and prisoners. Security was tightened, and some crackdowns occurred. Though the overcrowding and nasty conditions ensured that trouble was rarely far away, there wasn't another large-scale breakout attempt for some time afterward. The escape attempt marked a last hurrah of sorts for the ringleaders. None of them ever tried anything like it again.

Lonnie Taylor, now missing one arm, lost much of the fire that had made him so desperate. According to his buddy Woodruff, he became something of a celebrity inside, often emceeing the prison talent shows and cracking jokes with the audience, posing with folks who wanted to see the state's most notorious desperado. The two remained friends until Taylor was paroled in 1959.[137]

Rufus Guy seems to have had a rougher time of it. He became eligible for parole in 1964 and was released the following year. Incredibly, the last record in his file says that he was returned to the prison for parole violation in 1977, when he was sixty-nine years old. He spent only three months inside before being paroled for good in February 1978.[138]

And Horace Woodruff? He had the most remarkable story of all.

Following the break, he finally began to accept his fate and dedicated his time to improving himself. He found religion and began reading every book he could find. He was eventually allowed the privilege of learning radio repair and trusted with running the prisoner radio station. Most impressive, he finally renounced violence. When a friend tried to cut him in on a later escape attempt, he says he lectured the man about how futile gunplay was

against the authorities. He must have been convincing; to his surprise, his friend quietly got rid of the guns he had collected, and the escape never came off.[139]

During the 1950s, he befriended legendary Nashville journalist John Siegenthaler, who took up his case and worked tirelessly for his release. Despite stiff opposition from the family of Officer Mulvihill, the efforts finally paid off. On December 27, 1962, Governor Buford Ellington handed Woodruff his release papers, and he walked free. He had spent thirty-one years behind bars—over a third of that time in solitary confinement.

It's satisfying to know that he didn't waste his second chance. Changing the spelling of his last name to "Woodroof," he held a modest but honest job and continued to act as a voice for prison reform. In 1971, he wrote his autobiography, *Stone Wall College*, a harrowing account of his vicious past, as well as his rebirth into a better life. He died on June 1, 1975, at the age of sixty-nine. His body was donated to Vanderbilt Medical Center for research.

And as for the prison itself, it soldiered on for another six decades before being closed in 1991. Today, it still squats like a great gray gargoyle overlooking a city both repelled and fascinated by it. Like so many who spent time there, today it lies alone, unwanted, abandoned and facing an uncertain future.

And maybe that's the most fitting place for it to be.

HORROR ON THE LITTLE MARROWBONE

J ust a few miles outside downtown Nashville, the brick and steel buildings suddenly fade gently into wooded hills and valleys, a rugged and beautiful landscape little changed over the years. Even today, the area near the Davidson-Cheatham county line is rural and quiet, but during the 1930s the area was positively wild. It was an area of log cabins and wood-burning stoves, where the way of life hadn't changed in over one hundred years. This quiet setting became the scene of one of the most shocking and mysterious crimes of the era, a crime that was in many ways—like the area itself—a throwback to the nineteenth century.

January 30, 1938, was a bitter evening, with sleet and rain pelting down from a heavy sky. Folks in the area along "The Ridge" near Little Marrowbone Creek were huddled close to the fire to keep out the chill. The surrounding woods were dark in a way hard to comprehend today—electric streetlights were far in the future. That's probably why the glow from the woods grabbed a lot of attention almost immediately.

During a downpour around 8:30 p.m., the sky was stained orange as a building went up in flames. Those living nearby knew where the fire was, and most didn't seem to be too concerned. The hill was the site of Camp Dogwood, the first summer camp for African American children in Tennessee. Opened in 1929 by the Bethlehem Center of Nashville, it provided outside experiences for poverty-stricken kids from the city. Most of the locals thought that some local hellion or other had probably torched one of the cabins there, either accidentally or for fun. Few seemed concerned at first.

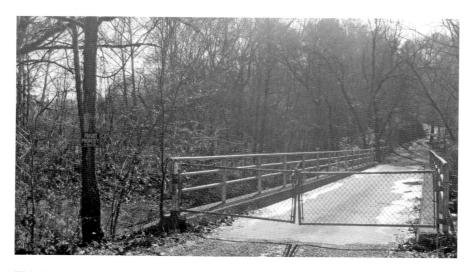

This desolate country road was the scene of one of the most heinous crimes of its era: the Marrowbone Creek murders. *Author's photo.*

By the next morning, more ominous stories were going around. Four young men had gone missing the night before, and rumor said the fire had something to do with their disappearance. A report was heard that two dark figures had been seen silhouetted against the flames, calmly watching the fire. A curious crowd soon gathered at the scene, and before long they had made a gruesome discovery.

The burned log cabin was an older building, known locally as the John Casey house. Nothing remained but a smoldering pile of foundation stones, but plainly visible in the rubble was a tangle of human bodies. Three charred corpses lay in a tangled heap within the foundation, and one more was seen on what had been the porch. When Sheriff Jack Keith showed up, he found Lee Nesbitt, a neighbor, standing guard to keep hogs out of the wreckage. Nesbitt said he'd happened by around seven o'clock that morning while heading toward Melvin Davenport's house. "We saw the cabin burn last night," he told a reporter, "but we didn't think anything but that the Negro camp was going up in smoke." That's when he said he saw the bodies, and all he could think of was the missing boys—"they had left our place just an hour before the fire to go home across Little Marrowbone."[140]

The bodies in the cabin were soon identified as the missing quartet. Three were local boys. Carney F. Brizentine was the oldest at twenty-five, F.M. Simpkins was twenty-two and Robert Louis Williams was the youngest at only sixteen. All of them were born and raised in the Marrowbone district.

The fourth was eighteen-year-old Bertram Spicer, a friend visiting from White Bluff in Dickson County. Grief-stricken family members identified the bodies from items found at the scene. Robert's father, W.T. Williams, broke down as he identified his son by his only worldly possessions: a dime and a pocketful of marbles, which were fused to his skin by the heat of the fire.[141]

Angry muttering went through the crowd, but incredibly, Sheriff Keith insisted there was no mystery—the deaths were accidental. The boys had obviously taken shelter from the rain in the abandoned cabin, then fallen asleep and died when the place went up in smoke. As county coroner, he even announced that there would be no autopsies, as the remains were already identified. The death certificates were filled out tersely: "Burned to a Crisp."[142]

That didn't sit well with many locals. It didn't add up, one witness pointed out. The boys had last been seen at the house of forty-nine-year-old Albert Davenport, about a half mile from the scene. They had left around 7:30 p.m.—less than an hour before the fire started. That left little time for them to stoke a fire and fall asleep.

Nevertheless, for the next few days, the sheriff held to his guns, shaking his head when the subject of foul play was broached. It left some wondering if a coverup was in the making.

Then, on February 2, the hammer fell. A sheriff's posse fanned out through the district looking for two men. A trap was laid for Albert Davenport at a still on his property, but he never showed. Later that night, he was arrested without incident when he tried to sneak into his home after dark. At a speakeasy known as Pat's Place, they picked up Lee Nesbitt, thirty, the "helpful neighbor" who had been guarding the ruins the day after the fire. Both men lodged in the Ashland City jail pending examination.[143]

At the hearing, a surprising witness came forward. Albert's daughter-in-law, May, testified against the accused. She was the wife of Melvin Davenport, whose cabin stood at the base of the hill below the camp, and her testimony was damning. She said that around nine o'clock on the night of the fire, Albert Davenport dropped in to let them know the cabin was burning. This was just half an hour after the fire had started. Nesbitt came in a few minutes later, and she said he made a chilling declaration: the boys were in the cabin. He told Melvin and May that he saw a hand in the fire "and that as he looked at it the hand closed and fell" into the flames.[144]

After examining the evidence, the authorities laid out what they thought had happened. The four boys left Albert Davenport's place around 7:25 p.m. They may or may not have been accompanied by one or two girls who lived

with the family. Shortly after they left, Davenport and Nesbitt followed them, one carrying a double-barreled shotgun and the other a double-bladed axe. According to the undertaker, two of the boys were shot in the chest, and the others were hacked to death. Three of the victims were decapitated, and all bore ragged chop marks as if an axe were used on them. "The skull of the Williams boy was missing and we could not find it at all," he added.[145]

After the murders, the killers doused the cabin with gasoline and set it ablaze to hide the evidence. The blade of the axe was found among the ashes the next day. It also appears that Nesbitt played the good neighbor and visited the family of one of the murder victims, sadly telling them that he'd discovered the boys' bodies.

Davenport and Nesbitt were both indicted for first-degree murder. Their trial opened at the courthouse in Ashland City on May 18, 1938. As could be expected in such a small town, the trial was big news, and hundreds of "hill people"—as the press condescendingly called them—packed into the building. Friends and kin of both victims and the accused sat side by side as the attorneys braced for a long trial.

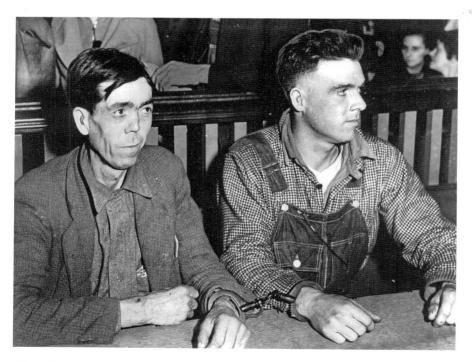

Albert Davenport (left) and Lee Nesbitt (right) listen to testimony during their trial for murder, 1938. *Author's collection.*

The prosecution's star witness was expected to be Louise Bass, an eighteen-year-old unwed mother who was one of eight people living in Albert Davenport's household at the time. She had sworn out two written statements before the trial in which she told what she said had really happened that night.

In her statement, she claimed that the four victims had been drinking at the Davenport home earlier that evening. After a pleasant get-together where Albert played the banjo and the group sang old-time songs together, the boys said goodnight. Several of them were inebriated as they left, heading toward the Marrowbone on their way home. Shortly afterward, Albert Davenport followed them with a shotgun and five shells, while Nesbitt trailed along carrying the axe.

After an hour, they returned, and Davenport had only three shells left. She claimed that he admitted that he'd shot Williams and Brizentine, while Nesbitt had taken care of the other two with the axe. Williams, she was told, was killed "to get him out of the way so he wouldn't be a witness against them." The gasoline, she said, was tapped from the tank of a car outside.[146]

It was a detailed and impressive statement, but Louise left much to be desired on the stand. She was visibly terrified during her testimony, and to the surprise of the attorneys, she promptly denied that the two defendants had anything to do with it. Now she said they hadn't left the house until after the fire. When confronted with her earlier sworn statement, she reversed herself.

Then the defense lit into her on cross-examination, and she reversed herself again. Eventually, Louise broke down completely under the pressure from both sides and had to be led away from the stand. In the end, she claimed that her sworn statement was untrue. She said she had lied when she was told that a young man who had promised to marry her was about to be charged with the crime, so she pinned it on Nesbitt and Davenport to protect him. She added that she was terrified someone might do her harm if she testified.[147]

Her fear may have been well deserved. Lee Nesbitt had been a hardworking foundry worker in Dickson County before his job disappeared during the Depression. He decided to go in with Davenport at a moonshine still he owned to make some money. Allegedly, Nesbitt had briefly abandoned his wife and lived with Louise for awhile, until his wife had sworn out a warrant against him. He reportedly patched things up with his wife and brought her back to the Davenport home with him.[148] Louise lived under the same roof and said she lived in fear of Mrs. Nesbitt's wrath.

The defense team must have been confident when it opened its case. Albert Davenport took the stand to vaguely deny his guilt. Lee Nesbitt was a far more sympathetic witness. The family man with the tarnished reputation emphatically denied he had anything to do with the murders. His testimony led to some of the most poignant moments in the trial.

As he spoke on the stand, his little girl approached and tried to climb into her father's lap, and his little son chirped, "Hi, Daddy!" several times from among the crowd. Mrs. Nesbitt stood staunchly by her husband and testified in his defense. While she spoke, her husband sat quietly listening while his son lay with his head in his father's lap. He gently stroked the boy's hair like any loving father might. It was a scene hard to reconcile with the state's image of a hardened killer, and the prosecution even objected unsuccessfully on the grounds that the defense was playing on the jury's sympathy.[149]

In the end, the defendants' testimony ended up backfiring badly. Nesbitt admitted that he knew the boys were missing that night and suspected they might be in the burning cabin. He saw the fire while leading Albert's cow back to the house from a nearby pasture. The prosecuting attorney was puzzled and asked if his friends were missing, why hadn't he checked on them? Nesbitt replied that he had charge of Albert's cow.

"Do you mean to say that a cow kept you from looking in to see if your friends had died in that fire?" he asked.

"Well," Nesbitt responded lamely, "I had the cow and couldn't let it go."[150]

In the end, despite the disaster with Louise Bass, there were too many holes in their story. The testimony of others such as Albert's daughter-in-law, May Davenport, eventually swayed the jury. On May 25, 1938, the jurors returned after only an hour of deliberation with their verdict. Judge W.W. Courtney read it to the hushed courtroom: guilty of murder in the first degree. As he finished, a voice boomed from among the spectators.

"Well, they're hard. They ought to be able to take it!"

As the courtroom erupted in tumult and the judge called for order, the two defendants said nothing. Nesbitt sat stone-faced and stoic. Davenport seemed to "wilt" in his seat. They were led back to jail as the defense team began prepping their appeals.[151]

During the legal wrangling over the verdict, yet another twist emerged in the case. After his wife, May, had testified for the prosecution, Melvin Davenport took her and moved to Nashville to avoid the wrath of any vengeful friends or relatives. However, he had unfinished business in Marrowbone, and in October, he went there to work on a moonshine still, despite his wife's misgivings.

State Penitentiary, Nashville, Tenn.

The Tennessee State Penitentiary. Davenport died here nearly twenty years after his conviction for murder. *Author's collection.*

Around sundown on October 7, 1938, an eighteen-year-old named Elmer Dickens turned himself in at the Ashland City Police Station, claiming he'd shot a man in self-defense. The victim was none other than Melvin Davenport, whom Dickens claimed had threatened his life. Others were not so sure. When the news was broken to May at her home in Nashville, she broke down crying and stated, "I told him not to go up on the Ridge again."[152] As she saw it, the whole affair was revenge for her own testimony against her father-in-law. Albert Davenport, who was being held in the same jail as his son's killer, reportedly broke down weeping when he was told of his son's death.[153]

Dickens was later tried and convicted of manslaughter. He got two years in prison.

In the end, the appeals failed, and the two convicted murderers were sentenced to ninety-nine years apiece to be served at "Old Red Top" in Nashville. Albert Davenport would never emerge alive. Twelve years in, he caught tuberculosis and died in the prison hospital on November 15, 1950, at the age of sixty-two. Nesbitt later saw his sentence reduced. He was quietly paroled in 1963.[154]

As for the victims, they were laid to rest in local cemeteries among the hollows they knew so well. They couldn't speak, and their convicted killers wouldn't, so the question still remains: why? What was the motive behind this most shocking crime?

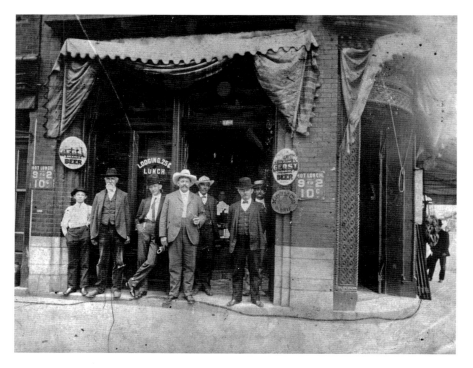

The Silver Dollar Saloon around 1900. Some say that the murders were connected to moonshining and Nashville's illegal liquor trade. *Courtesy Tennessee State Library and Archives.*

Was it jealousy? Louise Bass hinted that Nesbitt felt that Carney Brizentine was paying too much attention to his wife and did something about it. However, that explanation seems more than a bit weak. If he suspected Brizentine, why kill three other boys who had nothing to do with it? The tensions within the Davenport home probably played a role, but were they the overriding motive?

Another possibility emerged in the coming months. In 1939, federal indictments were handed down against the mayor of Ashland City and twenty other local citizens for violation of the liquor laws. The "revenuers" had been conducting their investigation for two years, and it was ongoing at the time of the murders. Several familiar names were on the indictment: Albert Davenport, Lee Nesbitt and Elmer Dickens, all of whom were at that time in cells at the Nashville prison.[155]

One of the murdered boys' own family members casually mentioned to a reporter at the scene that two of the four victims "were working together on a little business of their own" at the time they died,[156] so perhaps it was a falling out over a liquor deal gone wrong.

Was it business? Personal? Maybe a little of both? To this day, the questions remain unanswered.

"The shadows of four [murdered] youths . . . stalked through the Marrowbone district tonight."[157] So said a news report at the time Melvin Davenport was killed. And the reporter may not have been speaking figuratively. Rumor has it that for years to come, locals shunned the burned-out shell where the four boys died. Hunters are said to have seen strange lights and heard odd sounds there, and the story has it that shadowy figures were seen darting from tree to tree at twilight.

Perhaps, perhaps not. In the end, the crime, like so many others, was forgotten. Camp Dogwood is private property (read that as: no trespassing), still owned by the Bethlehem Center of Nashville. It sat derelict for many years after the murders, but in the early 2000s an attempt was made to renovate it and reopen for business. The plan seems to have fallen through, but it is nice to think that the scene of such a dark tragedy may still have a bright future ahead of it and that the scene of such suffering may once again be a place where children in need can enjoy a few days free from care.

For now, though, little has changed in the lonely spot on the Marrowbone. As happens so often throughout Nashville and the surrounding area, dreams of the future often walk hand-in-hand with the ghosts of the past.

NOTES

CHAPTER 1

1. *Tennessee Gazette*, July 21, 1805.
2. Andrew Jackson, letter of July 1805, in Harold D. Moser and Sharon McPherson, eds., *The Papers of Andrew Jackson*, Vol. II (Knoxville: University of Tennessee Press, 1980), 67.
3. Thomas J. Overton, letter of August 1, 1805, in Moser and McPherson, *Papers of Andrew Jackson*, 70.
4. James Parton, *Life of Andrew Jackson*, Vol. I (New York: Mason Bros., 1860), 286.
5. Ibid., 288.
6. *Tennessee Gazette*, June 28, 1806.
7. Parton, *Life of Andrew Jackson*, 295.
8. Ibid.
9. Ibid., 299.
10. Ibid.
11. L'Hommedieu Lodge, "Jackson and Dickinson," *Truth's Advocate and Monthly Anti-Jackson Expositor* (1828): 234.
12. Parton, *Life of Andrew Jackson*, 300.
13. Mary May Berry Martin, "Mrs. Mary L. Martin: A Noted Talk," *(Franklin, TN) Review and Appeal*, September 1, 1881.
14. Parton, *Life of Andrew Jackson*, 301.
15. Ibid.
16. *Tennessee Gazette*, August 9, 1806.

17. Cathy Lauder, "Charles Dickinson's Grave Is Found," CivicScope (Fall 2010), http://www.civicscope.org/nashville-tn/CharlesDickinson.

Chapter 2

18. Parton, *Life of Andrew Jackson*, 387.
19. Ibid., 388.
20. Andrew Jackson and John M. Armstrong, letter of August 23, 1813, Andrew Jackson Papers, series 6, vol. 158, MSS 27532, Library of Congress.
21. Parton, *Life of Andrew Jackson*, 392.
22. Ibid., 393.
23. Ibid., 394.
24. Thomas H. Benton, letter of September 10, 1813, in Moser and McPherson, *Papers of Andrew Jackson*, 245.
25. John F. Kennedy, *Profiles in Courage* (New York: Harper & Row, 1957), 105.

Chapter 3

26. Minute Books, Davidson County Circuit Court, Roll 522, Tennessee State Library and Archives.
27. Ibid.
28. *Nashville Whig*, July 27, 1843.
29. *South Western Law Journal* (September 1844): 211.
30. Ibid., 212.
31. *Nashville Republican Banner*, January 6, 1845.
32. *Nashville Union & American*, November 15, 1861.
33. "John McCline" in *Slavery in the Clover Bottoms*, edited by Jan Furman (Knoxville: University of Tennessee Press, 2005), 34.
34. Ibid., 17
35. Ibid., 32.
36. Ibid.
37. *Nashville True Whig*, October 26, 1853.
38. Ibid.
39. *Loudon Free Press*, November 4, 1853.

Chapter 4

40. *Nashville Whig*, March 17, 1846.
41. Ibid.
42. Ibid.

43. Ibid.
44. *Pittsburgh Daily Post*, March 25, 1846.
45. Ibid.
46. *Knickerbocker: Or, New-York Monthly Magazine* 27, no. 5 (May 1846): 466–67.
47. *New York Times*, August 20, 1855.

CHAPTER 5

48. *Daily Union*, November 11, 1865.
49. *Republican Banner*, November 21, 1865.
50. *Daily Dispatch*, November 24, 1865.
51. Ibid., November 28, 1865.
52. Ibid.
53. Richard W. Johnson, *A Soldier's Reminiscences in Peace and War* (Philadelphia: Lippincott, 1886), 305.
54. *Daily Dispatch*, November 26, 1865.
55. "Ellen Renshaw House," in *A Very Violent Rebel*, edited by Daniel E. Sutherland (Knoxville: University of Tennessee Press, 2008).
56. *Republican Banner*, December 14, 1865.
57. Ibid., December 20, 1865.
58. *Daily Dispatch*, January 25, 1866.
59. Ibid., January 27, 1866.
60. Ibid.
61. *Union and American*, January 27, 1866.

CHAPTER 6

62. *Nashville Daily World*, November 24, 1884.
63. *Nashville American*, November 24, 1884.
64. William R. Cornelius, "Embalming During the War," *Modern Embalmer*, July 1892.
65. *Nashville American*, June 6, 1885.
66. Ibid.
67. *Nashville Press & Times*, October 20, 1866.
68. Ibid., October 23, 1866.
69. *Daily Dispatch*, October 23, 1866.
70. *State v. W.S. Bond* [sic], Tennessee Supreme Court Cases, Tennessee State Library and Archives.
71. *Nashville American*, July 6, 1883.
72. *Daily World*, July 10, 1883.
73. *Nashville American*, November 1, 1888.

74. Ibid., May 30, 1895.
75. Ibid., May 31, 1895.
76. Ibid., June 3, 1895.
77. Ibid., April 16, 1896.

CHAPTER 7

78. *Nashville American*, January 19, 1886.
79. Ibid., January 22, 1886.
80. Ibid., March 1, 1886.
81. *State v. Ben Brown*, Tennessee Supreme Court Cases, Tennessee State Library and Archives.
82. *Nashville Banner*, March 4, 1886.
83. *Nashville American*, March 13, 1886.
84. Ibid., April 10, 1887.
85. Ibid., April 16, 1887.
86. Ibid., September 27, 1888.
87. Ibid., February 27, 1888.

CHAPTER 8

88. *Nashville American*, December 7, 1903.
89. Ibid.
90. Ibid.
91. *Nashville Banner*, December 7, 1903.
92. *Nashville American*, December 7, 1903.
93. *Nashville Daily News*, December 8, 1903.
94. *Nashville Banner*, December 12, 1903.
95. *Nashville American*, February 12, 1904.
96. *Nashville Daily News*, December 8, 1903.
97. *Nashville Banner*, May 3, 1905.
98. Ibid.

CHAPTER 9

99. Charles T. Cates Jr., ed., *Reports of Cases Argued and Determined in the Supreme Court of Tennessee*, Vol. XV (Columbia, MO: E.W. Stephens, 1911), 158.
100. Ibid., 178.
101. *Nashville American*, November 10, 1908.
102. Cates, *Reports*, 231.

103. Ibid.
104. *Nashville American*, August 31, 1919.

Chapter 10

105. Ed Huddleston, "The Bootleg Era," *Nashville Banner*, 1957.
106. *Nashville Banner*, February 6, 1924.
107. Death Certificate, Tennessee State Library and Archives (TSLA).
108. *Tennessean*, December 9, 1913.
109. Huddleston, "Bootleg Era."
110. Ibid.
111. *Nashville Banner*, August 17, 1927.
112. Ibid.
113. *Tennessean*, July 19, 1933.
114. *Nashville Banner*, July 4, 1933.
115. Death Certificate, TSLA.
116. *Tennessean*, July 9, 1933.
117. *Nashville Banner*, July 13, 1933.
118. Huddleston, "Bootleg Era."
119. Inmate Records, Tennessee State Prison, RG 25, TSLA.
120. *Tennessean*, March 14, 1918.
121. Official Gazette of the United States Patent Office, Vol. 197 (Washington, D.C.: Government Printing Office, December 1913), lxvi.
122. *Tennessean*, February 21, 1936.
123. Death Certificate, TSLA.

Chapter 11

124. Horace Woodroof, *Stone Wall College* (Nashville, TN: Aurora, 1970), 78.
125. Ibid., 6.
126. Inmate Records, RG 25, TSLA.
127. Ibid.
128. Woodroof, *Stone Wall College*, 94–95.
129. Ibid., 114.
130. Ibid., 116.
131. *Nashville Banner*, "Directions for Chase Given Under Fire," November 10, 1938.
132. Ibid.
133. *Nashville Banner*, "Officers Tell of Battle with Convicts," November 10, 1938.
134. Ibid., "Eyewitness Tells of Battle," November 10, 1938.
135. Woodroof, *Stone Wall College*, 124.

136. Death Certificate, TSLA.
137. Woodroof, *Stone Wall College*, 154.
138. Inmate Records, RG 25, TSLA.
139. Woodroof, *Stone Wall College*, 171.

CHAPTER 12

140. *Tennessean*, "Murder Seen as Four Die in Cabin Fire," February 1, 1938.
141. *Nashville Banner*, "Ashland City Farmer Tells of Finding Son," May 18, 1938.
142. Death Certificates, TSLA.
143. *Tennessean*, "Woman Links Two in Cabin Murder," February 5, 1938.
144. Ibid.
145. Ibid.
146. Ibid., "Girl Accuses Two of Deaths," May 20, 1938.
147. *Nashville Banner*, "Girl Witness Repudiates Her Testimony," May 20, 1938.
148. Ibid., "Cabin Murder Verdict May 'Clean Up' Ridge," May 26, 1938.
149. Ibid., "Defendents [sic] Deny Killing Four Youths," May 21, 1938.
150. *Tennessean*, "Murder Jury Is Locked Up," May 22, 1938.
151. Ibid., "Forlorn Families Hear 99-Year Sentences for Nesbitt and Davenport in Cabin Deaths," May 26, 1938.
152. Ibid., "Ridge Murder, Cabin Deaths May Be Linked," October 10, 1938.
153. Ibid., "Youth Claims Self Defense in Murder Case," October 9, 1938.
154. Prison Records, RG 25, TSLA.
155. *Tennessean*, "Ashland City's Mayor, 22 Held in Liquor Case," May 18, 1939.
156. Ibid., "Murder Seen," February 1, 1938.
157. Ibid., "Youth Claims Self Defense," October 9, 1938.

ABOUT THE AUTHOR

Brian Allison has worked in the public history/museum field for around twenty years. His past experience includes curating, public speaking and creating documentaries. Brian holds a degree in American history from Austin Peay State University. He has also worked as a staff historian for several local museums and served as curator for Travellers Rest Plantation. Brian is co-author of *Tennessee State Penitentiary*.